CAPTAIN COOK COUNTRY
THROUGH TIME
Alan Whitworth

AMBERLEY PUBLISHING

First published 2013

Amberley Publishing
The Hill, Stroud
Gloucestershire, GL5 4EP

www.amberley-books.com

Copyright © Alan Whitworth, 2013

The right of Alan Whitworth to be identified as the
Author of this work has been asserted in accordance
with the Copyrights, Designs and Patents Act 1988.

ISBN 978 1 4456 0616 3

British Library Cataloguing in Publication Data.
A catalogue record for this book is available from
the British Library.

Typeset in 9.5pt on 12pt Celeste.
Typesetting by Amberley Publishing.
Printed in the UK.

Introduction

Captain James Cook, RN, is to exploration and navigation what William Shakespeare is to the English language and literature. James Cook is probably the most iconic and celebrated Yorkshire man the county has produced among a bevy of famous Yorkshire names. More than that however, his life and career made him a national hero and the epitome of a brave and determined man. His three voyages of exploration and his work for the Admiralty when serving in Canada, undoubtedly led to the discovery of more of the world than any other maritime adventurer, at any point in history. How he became a national treasure is remarkable given his humble ancestry in an era divided and aggregated by class. James Cook transcended social boundaries to achieve the posthumous granting of a coat of arms by King George IV.

Linked with his name, is the seaport of Whitby and the three ships that he chose to employ on his circumnavigation of the globe into uncharted waters. This was also the place where he learnt his skills as a seaman and, while Australia can boast of a full-size replica of the HM *Bark Endeavour* that visited Whitby in 2009, the town can nevertheless add to the memorabilia that the life and voyages of Captain Cook inspired.

Ship building has been a tradition in Whitby for hundreds of years and this project to recreate a small scale model of HM *Bark Endeavour*, helps to keep these memories alive today. The wooden replica is two-fifths the size of the original ship, but it was built using the same techniques and skills employed 250 years ago.

If Captain Cook was to visit the replica of the *Endeavour*, he would be delighted by the accuracy of the work and high standards of construction achieved in Whitby, where his first ship was built. He would also be intrigued by the twenty-first-century components of the vessel and safety requirements of modern seafarers. But, being a man who was always ready to embrace new technology, he would be very excited by the advances made since his day.

The main differences between the original and the replica are the actual timbers used, the preservatives such as modern paints, the metal fittings and the use of manmade materials for the sails and some of the ropes. Instead of traditional oak, elm and spruce, this replica is built mainly from oak frames and larch planking and 'Douglas Fir' decking.

James Cook's actual ship (the HM *Bark Endeavour*) was originally built in 1765 as a three-masted collier, named the *Earl of Pembroke*, but was renamed three years later when it was put into service for the Royal Navy. These eighteenth-century collier craft, known locally as 'Whitby

Cats', were remarkably sturdy and seaworthy. Constructed with flat bottoms, they were ideal for exploration and hydrographic purposes and the Navy paid £2, 800 for her from the owners.

Work on the replica started on the site in the shipyard of Parkol Marine in May 2001 with the aim of the ship leaving the shed sometime in March 2002. The masts and rigging were fitted on the water for her new life as a passenger vessel operating in the harbour from Easter 2003. The Keel was laid in May 2001 and the next stage was to fit the lofting to enable the templates to be made for the hull. Coins were placed in the number 7 mid-ships' frames for good luck. Larch planking was put in place over the wooden frame during the autumn months and decking was fitted in January 2002. On completion, she was 44 feet long, 13 feet wide and carried up to 40 paying passengers.

The project is being financed by the Jenkinson family, who have been involved in fishing in the town for decades. As you look at the ship, the bow (front) is on your left and the ship's design is carefully marked out on the hardboard base. Nowadays, vessels are built in the shipyard using computer technology, but in James cook's times, different techniques were used. On the opposite side of the harbour to where you are now, a shipwright's sculpture has been commissioned to depict Whitby's ship-building past and remind visitors of how wooden craft used to be built in the town.

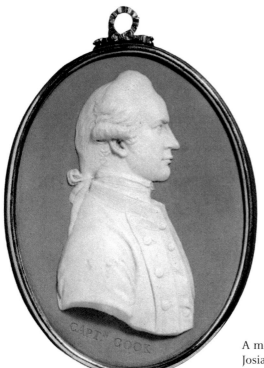

A medallion portrait of James Cook (1728–79) by Josiah Wedgwood, from a design by John Flaxman, cast in 1784.

Capt. James Cook, RN

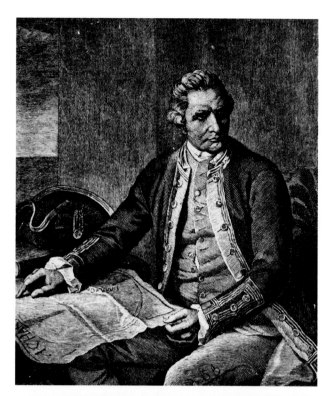

In life he did his duty and in death he became a legend, which he did not live to enjoy. Murdered by natives on the island of Tahiti, he was buried at sea on the voyage home. Artists and sculptors vied to represent his noble life and deeds through portraiture and cameos. John Flaxman (1755–1826) created a bust in 1784 that was later the inspiration for Josiah Wedgwood (1730–1795) when he created a medallion portrait. Nathaniel Dance (1736–1811) painted his likeness (bottom right) in Naval uniform consulting a chart of the globe, consisting of many of the countries that he discovered, which was copied in many guises and reproduced in numerous printed engravings (top right) that came to adorn the walls of every proud Englishman's home. In 1774, Cook believed, 'I, who hope ambition leads me not only further than any other man has been before me, but as far as I think it possible for a man to go.'

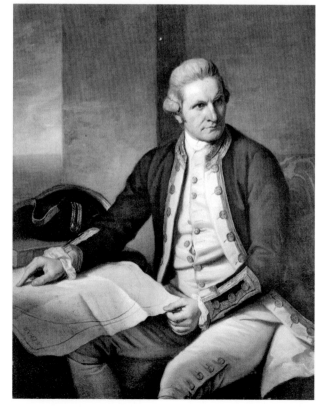

5

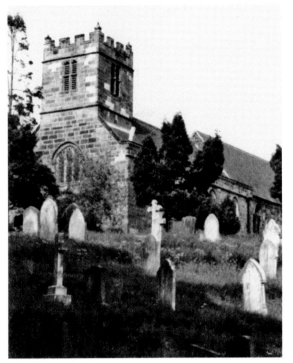

Cook Family Ancestry

James Cook was born at Marton, Yorkshire, in 1728. He was the second child in the family of James and Grace Cook. His parents had been married three years previously in the neighbouring village of Stainton, when they were thirty-one and twenty-three years old respectively. The register of the parish church still bears, in fading ink, the record of their marriage: James Cook and Grace Pace married on 10 October 1725. Although neither bride nor groom came from the village of Stainton, this was Grace's parish church as her family came from Thornaby, a small village by the River Tees, two miles to the north. In contrast, her husband appears to have had no local connections. He was a Scot and had been born just over the border, in the village of Ednam in Roxburghshire in 1694. He probably had a strict religious upbringing, for according to church records, his father was an elder of the church and would therefore have been 'responsible for the spiritual and temporal welfare of the parish'. The Ednam Kirk Sessions indicate that his father, John Cook, was a tailor. When and why Cook's father came to Cleveland is not known. He was at that time a day labourer going from farm to farm seeking whatever work was available. He was one of thousands of itinerant agricultural workers and of such little social importance at the time that his movements left few foot prints in the sand.

Stainton Church & Churchyard

Stainton, a parish in the 'wapentake' and liberty of Langbaurgh, 4 miles north-west of Stokesley. The church, dedicated to St Peter, is an ancient neat structure, but partly modernised having received great repair some years ago. It stands on elevated ground, at the western extremity of the village, with the vicarage house adjoining. This is a large and spacious mansion and the patronage of the Archbishop of York and the Hon. and Revd Henry Howard in the incumbent. In the chancel is the ancient sepulchre of the Pennyman family *c.* 1820.

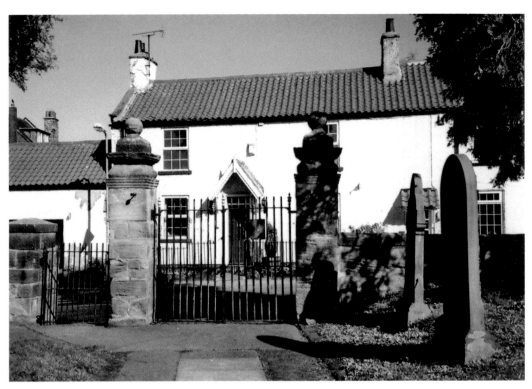

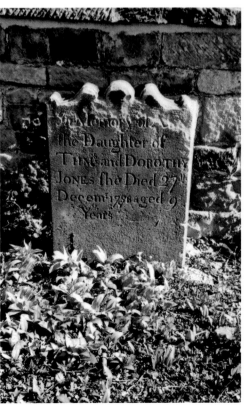

Gone but not Forgotten – Stainton Churchyard

Stainton is now a village within Middlesbrough, in the county of North Yorkshire. It is in the local ward and civil parish of Stainton and Thornton and in 2005 had a population of approximately 2,300. Stainton in one of the few areas within the boundaries of modern-day Middlesbrough named in the Domesday Book of 1806. Indeed, it was a settlement pre-Saxon times and its name also reveals it was an area of Scandinavian residence. Stainton Church dates back to the twelfth century.

Early Days

The parish of Ormesby contained several farmsteads that needed a willing labourer like James Cook (senior). A little over a year after their marriage, their first child was born. He was baptised at St Cuthbert's church, Ormesby, and continued to support the tradition of living in the parish. They named their child John after both of their fathers. With his wife's employment opportunities now limited by their baby, James wanted to secure a good job. With this in mind, the family moved to the nearby village of Marton. Below, a charming view of the former Captain Cook Memorial School at Marton, which was built in 1850 and closed in 1963.

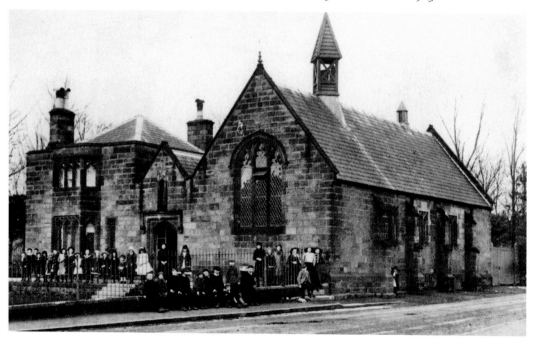

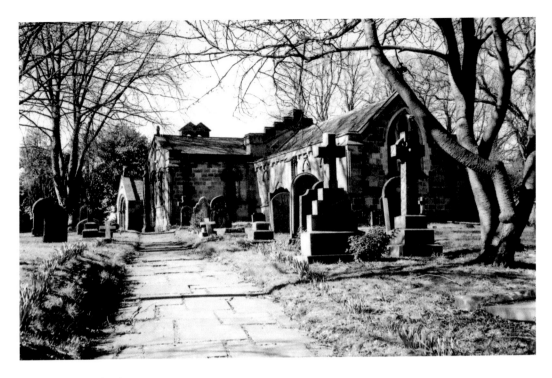

In the Beginning

The earliest biographies of Cook state his parents moved to Marton immediately after their marriage. Marton was not so much a village, but an area of rich farmland situated midway between the villages of Ormesby and Great Ayton. It was in the church of St Cuthbert at Marton, that the child James Cook was baptised on 3 November, after he was born on 27 October 1728. In the present day, the priest and parish are often very busy, as the church is generally not open on weekdays.

Captain Cook Connections

James Cook was baptised at St Cuthbert's church, Marton, 3 November 1728. The church register from that time is proudly displayed in the church, in a case made especially for it and records, 'James ye son of James Cook day labourer bapti[s]ed' [note: mothers' names were not recorded until 1777]. In the church on the south wall you will find a 'Memorial to Captain James Cook'. This was originally erected by the parishioners of Marton in 1812. It was removed during the 1840 rebuild and incorporated in the Captain Cook Memorial School, which was returned to the church in 1989 when the parish sold the school. James was born in low cottage, in what is now Stuart Park, which is just across the road from the church. The original cottage was demolished by the Rudd family, who mainly financed the 1840 refurbishment and the parkland around Marton Lodge. Almost seventy years later, H. W. F. Bolckow bought the ruins of the 'Lodge' and parkland and, in 1858, erected the granite vase that now marks the site of the cottage. It is next to the modern Captain Cook Birthplace Museum. In the chancel, the wooden panelling was given by the Brunton family in 1914 as a memorial to Robert and Mary Brunton. The Cook window commemorates members of the Bolckow family. The St George window is in commemoration of the men of Marton who made the supreme sacrifice in two wars – 'Faithful Until Death'.

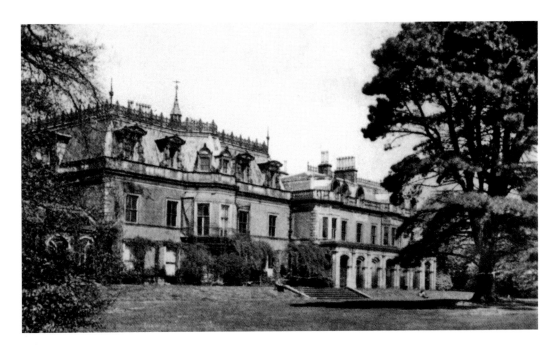

Marton Hall
Built for Mr H. W. F. Bolckow as his private residence in 1853, Marton hall was a magnificent house containing a marble staircase and many valuable works of art. After a period of standing empty, the hall and grounds were purchased from the descendants of Bolckow in 1923 by Councillor T. D. Stewart, a former mayor of Middlesbrough, and were presented to the town. He formally opened the park in 1928 and named it 'Stewarts Park' after himself. Sadly, the hall was demolished in 1960 following a fire. It was in the grounds that the former cottage of the Cook family stood.

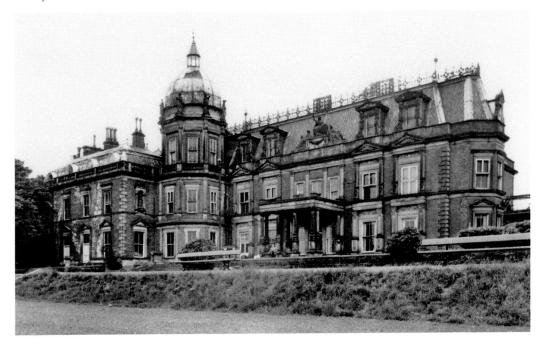

The Bolckow Legacy

The chancel stalls in St Cuthbert's were put there in the Victorian period for the exclusive use of the Bolckow family who were Lords of the Manor and connected with Marton Hall. There are memorials to some of them on the walls and the window. The communion rails were the first of Henry (below) and Bessie Bolckow to commemorate the 50th anniversary of their wedding, which took place here in 1890. Henry made his money in the iron industry and through ship building with his partner, John Vaughan, who lived at Gunnergate Hall until his death in 1868.

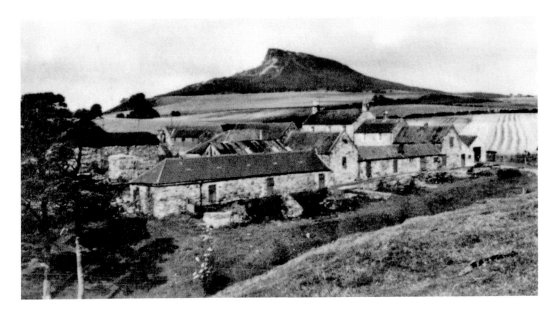

Aireyholme Farm, Great Ayton

Above is Aireyholme farm, Great Ayton *c.* 1975, with Roseberry Topping in the distance. Below is the farm shortly after the death of James Cook, by an anonymous artist. Little had changed in two centuries except for the Victorian addition.

The Cook family moved to Great Aryton and the farm where his father was employed as a farm labourer. The move introduced Cook to a village with a school. His father's employer, Thomas Skotowe of Aireyholme farm, paid for young James to attend the village school where he learned 'reading, 'riting and 'rithmetic'– the three 'Rs' that were considered necessary for a scholar.

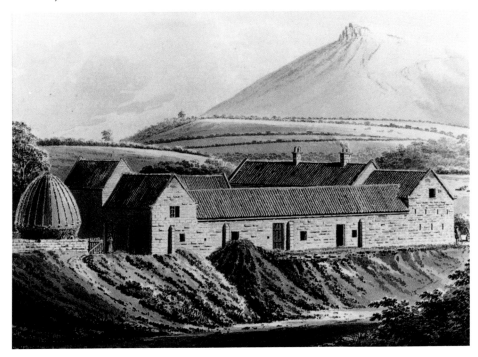

Aireyholme Farm & Roseberry Topping

Photographed above *c*. 1905, with the then owner and staff, is Aireyholme Farm. Visible are the proportions of the old farmhouse on the right and the expanded accommodation added during the Victorian period. Undoubtedly the reason for the seemingly enormous addition would be an increase in staff necessary to run a large farmstead in the nineteenth century. Below, we see the distinctive profile of Roseberry Topping from the duck pond at Aireyholme farm, which still survives as a depression in the landscape, but is mostly dry in today. Such a pond here is not fed by a spring but is more correctly known as a dew pond.

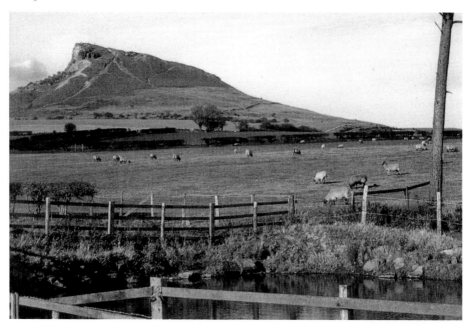

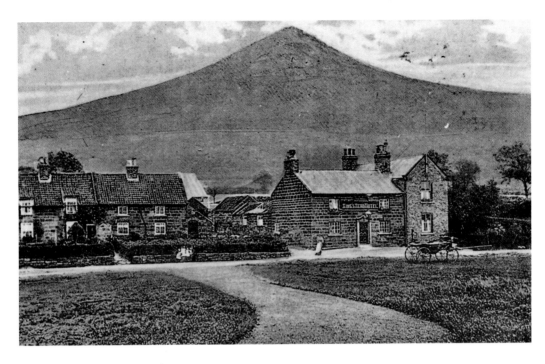

The Yorkshire Matterhorn

Known as the Yorkshire Matterhorn because of its unusual shape, the 1,057 feet high Roseberry Topping is a landmark of the northern moors. It lies on the Cleveland border and visitors have scaled its heights to enjoy the views from the sixteenth century according to the dates of the graffiti found carved on its rocks. There is a holy well near its foot and a hermit once lived in a cave halfway up. The discovery of ironstone led to extensive mining, which eventually caused the collapse of one side in 1914, resulting in its famous outline.

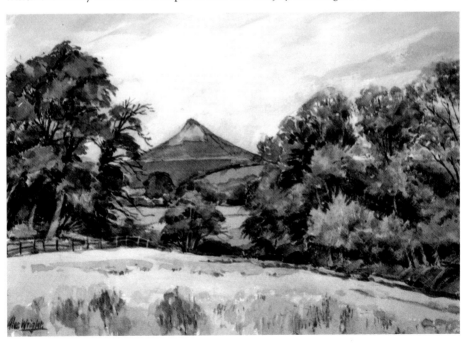

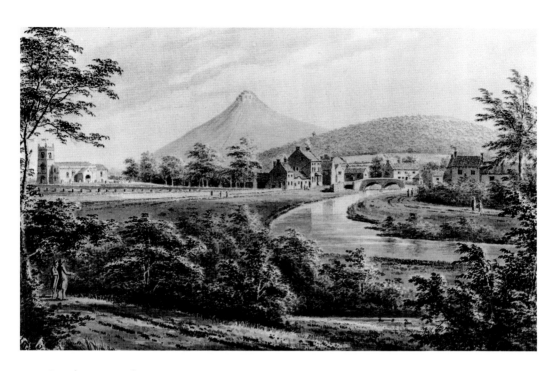

Roseberry Topping & Great Ayton

The top illustration shows a painting of Great Ayton by an unknown artist from the south-east with Roseberry Topping in the distance before its partial collapse. The town bridge can be seen and the large house nearby is said to have been one of two properties built in Great Ayton by James Cook, senior. Across the bridge a 'round house', which was the village lock up, is visible. If it is correct that Cook's father erected housing in the village, he must by this date have graduated from being a farm labourer into becoming a builder – a considerable step up in his social standing.

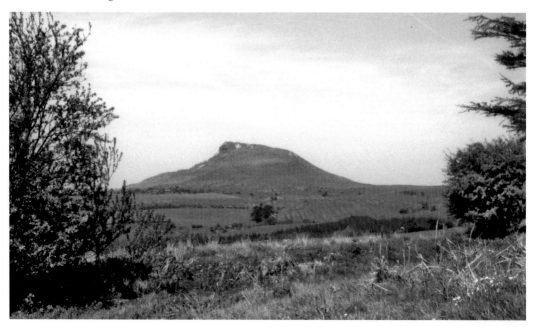

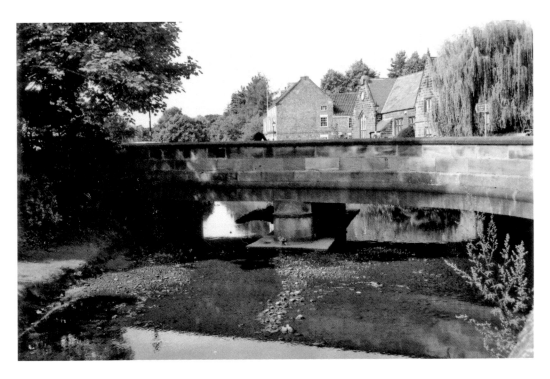

Great Ayton Bridge

The bridge today, is a replacement for the crossing of Cook's time. Much of the village is now a conservation area, with the River Leven and spacious greens enhancing the peaceful scene. Below, the parapet of the present bridge, dated 1909, attempts to conceal the village name from the Second World War, when it was thought that there may be an invasion of England by German paratroopers. At this point, signs were ordered to be taken down and attempts were made to deface carved names. In many cases, this was done half-heartedly out of respect for the antiquity of the structure, as shown here.

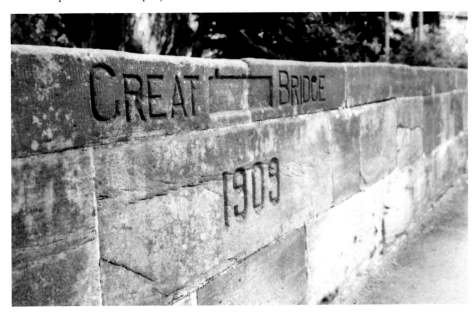

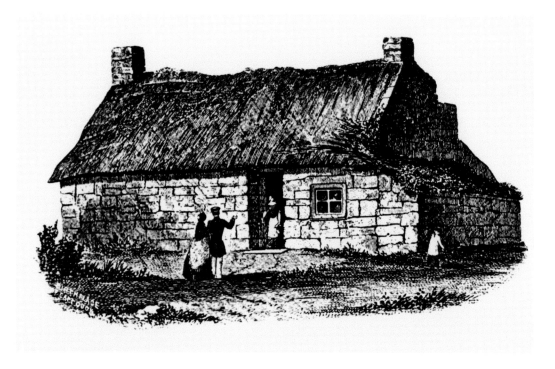

The Captain Cook Cottage

Above is a woodcut illustration of the old thatched cottage in which James Cook was born on 27 October 1725. This humble construction stood on the farm land of Thomas Skotowe, who owned Aireyholm Farm. The cottage was demolished in 1768 to make way for the erection of a large mansion, which later became Marton Hall and was eventually destroyed by a fire. However, as suggested by the well-dressed gentry, by the date of its destruction, it had already become a visitor attraction on the Captain Cook Trail.

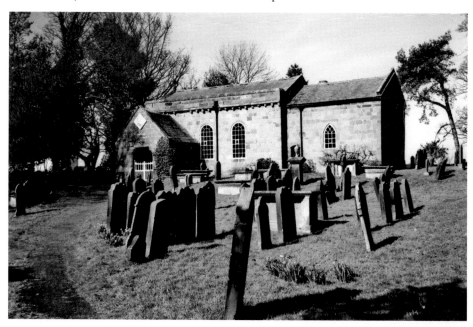

All Saints', Great Ayton – The Old Church

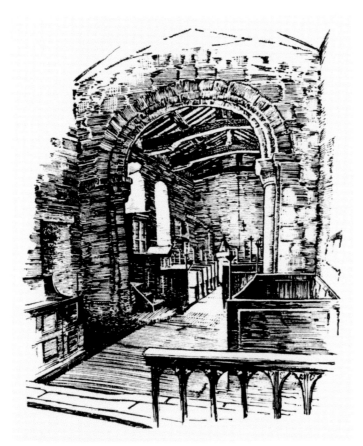

A sketch of the interior of the old church of All Saints', Great Ayton, by Alex Wright that shows the boxed pews and three-decker pulpit. This is the Church of the Revd Ralph Jackson who gave his report on the parish in 1743. He would preach here, but not from this pulpit for the church was not fully restored until 1788 by the Marwood family. The origins of the church lay in the Norman period and there is a great deal of excellent Normal work to be viewed – such as the Norman chancel arch and the Norman doorway with its finely decorated tympanum.

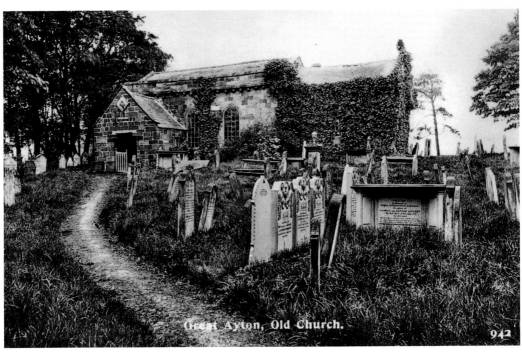

Great Ayton, Old Church.

942

The Family Grave

Within the cartilage of the churchyard of All Saints', the graveyard of some of the Cook family members can be found. James the second son and famed explorer, is not buried here and nor is his father. The inscription seen above, records only the interment of his mother, Grace Cook, who died 17 February 1768 aged sixty-three years, along with the mention of five of Cook's brothers and sisters. Indeed, the abbreviated inscription shown has been thoughtfully carved on the back of an eighteenth-century gravestone in modern times to assist readers and photographers on the Captain Cook Trail. The front actually faces north and is difficult to photograph, but is really the most attractive face with its cherubic angelic head, puffed out cheeks and curly hair, in floriated scrollwork typical of headstones in that period. The sundial that adorns the porch of All Saints' is also typical of eighteenth-century fashion in an era when clocks were scarce and watches were the prerogative of gentry folk. Nevertheless, it was understood that punctuality was a necessity even for workers who needed to know the hour in order to turn up for work on time or, more importantly, church. It is here that the Cook family would worship alongside their master every Sunday and Holy Day.

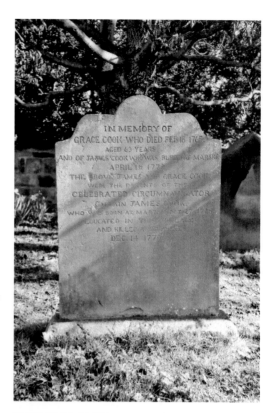

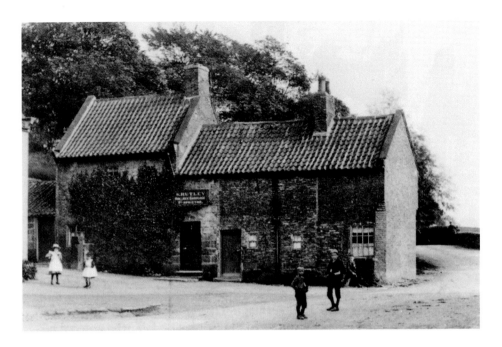

Captain Cook's Cottage, Great Ayton
Although James left the village when he was sixteen, his family stayed on the Aireyholme until 1755, when they built their own cottage of stone and brick (seen above before half of it was demolished in 1928 to widen the road during improvements). At that date, a man called Minchin lived in the right-hand half; he ran a carriage service and would transport passengers from the railway station for the price of 6*d*. The bottom photograph shows Cook's cottage as it was between 1928 and 1934 when it was taken down brick by brick and transported to Australia.

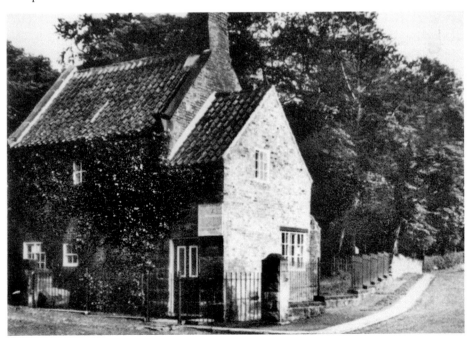

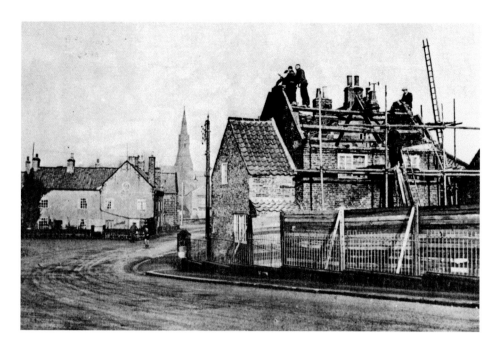

History Under the Hammer

In 1933, while the country slowly recovered from the Depression of the 1920s and the General Strike of 1924, Mr and Mrs Dixon decided to put the park ruinous Cook Cottage up for sale and an auction was arranged for Wednesday 28 June 1933. Such was the interest of the sale that it was mentioned in the *Australian Press*. The Government of Victoria (Australia) approached the Dixon family and after correspondence it was sold for £800. The clause inserted into the sale deeds prohibiting its removal from the country was amended to read 'not outside the Empire'.

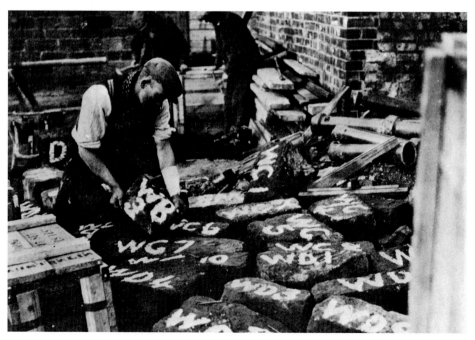

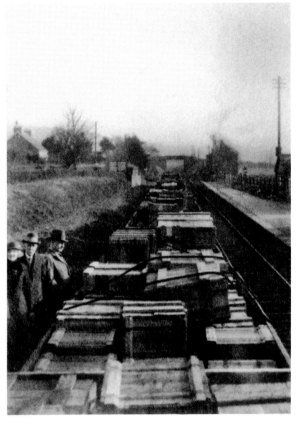

Cook's Cottage – The Long Goodbye

Before the cottage was carefully dismantled for its journey to the other side of the world, a notice was placed at the entrance that read 'The Government of Victoria (Australia) purchased Captain Cook's house for transfer to Melbourne, Australia, where it will be re-erected for the Victoria Centenary celebrations and preserved as a monument to the discoverer of Australia. The house will be allowed to stand for one month before being removed under skilful supervision and, during this time, will be opened to the public for inspection at a charge of 3*d* per adult and 1*d* per child. The proceeds will be equally divided the North Ormesby Hospital the North Riding Infirmary of Middlesbrough. No charge will be made of school children if accompanied by their teacher. Richard Linton, Agent General for Victoria.'

The cottage was taken down and packed into 230 wooden crates and loaded onto railway wagons at Great Ayton station, where they were destined for Hull docks and shipment to Melbourne. At the time of the sale, the cottage was owned by three Dixon brothers: William, Hansell and Arnold. Two 'Miss Hunters' married two of the Dixon brothers – Elizabeth married Hansell and Arnold married Anne. In the bottom photograph, the cottage is shown as now erected in the Fitzroy garden in Melbourne, Australia.

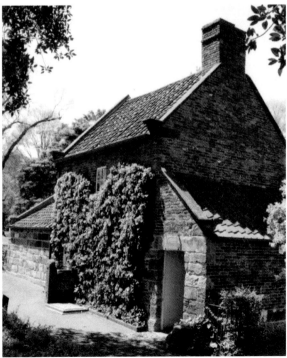

The Journey: A Beginning

In 1772 Captain Cook's father sold the cottage and went to live with his daughter Margaret in Redcar and, over the years, the cottage changed hands many times. In 1873, one hundred years later, it came into the ownership of the Dixon family, who have lived in Great Ayton for well over 300 years. The cottage was occupied constantly through those sixty years at a rent of 2/6d a week. It had originally been either one much larger, or two smaller cottages, but in a road widening exercise, practically half the cottage was swept away, leaving it as it looked at the time of sale. One newspaper reported such an unfounded story, that while it was empty and without a tenant, souvenir hunters became aware of the historic significance of the old building and gradually the cottage came to be at risk of being demolished. Great Ayton Parish Council showed no interest whatsoever at that time in preserving it, although there was much regret and a degree of bitterness about it when it had gone and many thought it should have been kept as a tourist attraction. The above photograph shows the official unveiling of the monument placed on the site of the Cook Cottage at Great Ayton, which took place on 15 October 1934.

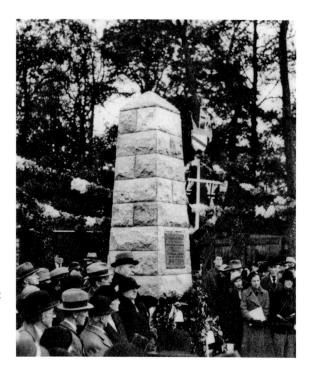

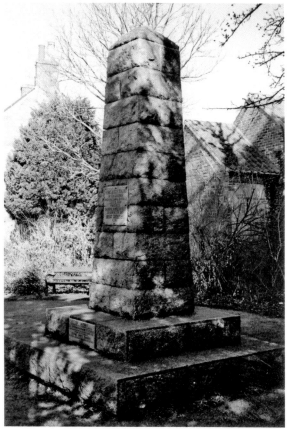

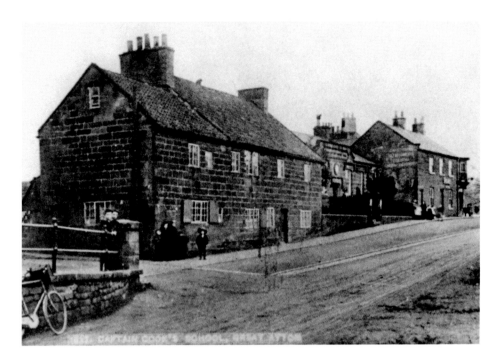

Postgate School, Great Ayton

The largest school at Great Ayton was founded by the Quakers and runs the length of High Green. This school took only pupils with parents that were 'Friends' or had Quaker associations. For the rest of the village and neighbourhood, there was Michael Postgate's School, erected in 1704 and rebuilt in 1785. It was this educational establishment that James Cook attended; the fees paid for by his father's employer. In 1851, Postgate's School was superseded by another school erected at the expense of G. Marwood of Busby Hall and largely supported by him during his lifetime.

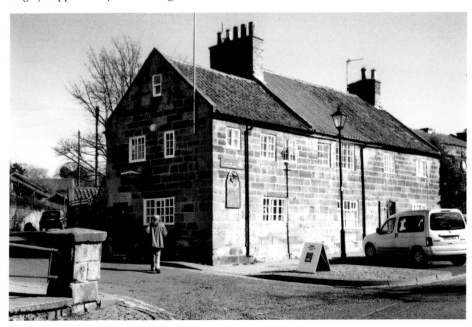

New Life for Old

This establishment was originally known as Marwood's Grammar School and when that closed it became the library. In 1843, the British School was erected by subscription at a cost of £500 for the education of fifty boys and fifty girls without respect for creed or persuasion. The Postgate's School, with other buildings, was converted into a dwelling house and let for £10 per annum, which was split in equal shares between Marwood's and the British School. Later, Postgate's School was acquired and became a museum. Inside the newly-refurbished museum, a small area has been set aside in the manner of a reconstructed classroom from the old school.

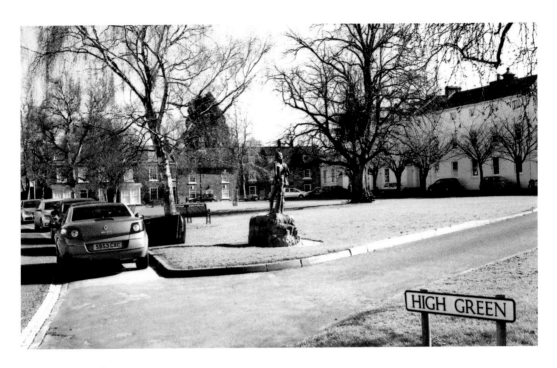

The Environs of Great Ayton

Great Ayton, or 'Canny Yatton' as it is locally known, is a large and handsome village consisting of a single broad street divided in to two parts by the River Leven. The parish comprises the townships of Great Ayton, Little Ayton, Tunstall and Nunthorpe. Ayton Magna at the time of the Domesday Book contained three distinct manors, which were subsequently untied. High Green is partly bounded on the top side by the Friends' School. The below photograph shows a recent extension to the village named 'West Terrace', captured in 1910. The Buck Hotel is off to the left and the village pump has gone.

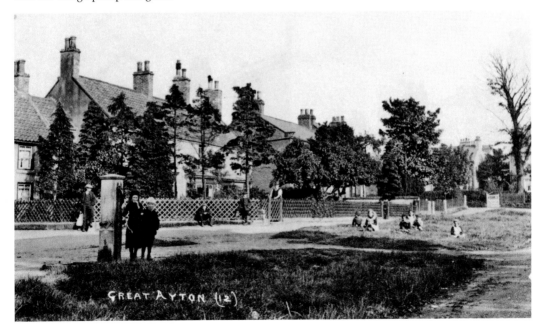

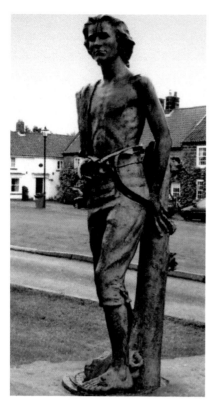

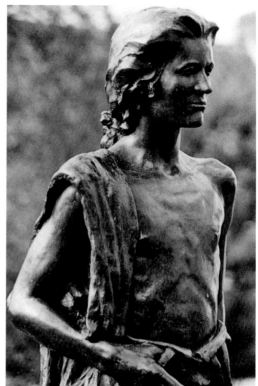

A Young James Cook

When the cook family arrived in Great Ayton, where his father was to be employed as a bailiff on the Aireyholme farm estate, James was eight years old. This bronze sculpture, located on High Green, depicts James at the age of sixteen when he left for Staithes and shows him looking towards the place where, according to tradition, he first felt the lure of the sea. The sculpture was commissioned by Hambleton District Council and Great Ayton Parish Council and is the work of sculpture Nicholas Dimbleby. It was unveiled on 12 May 1997.

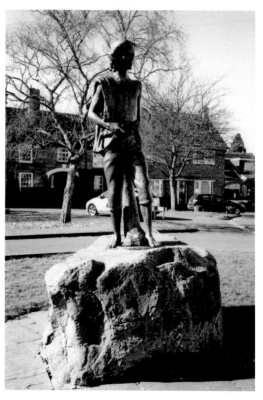

In Times of Trouble

Two views of Captain Cook country across the moors, where the prospects of wide open landscapes are reminiscent of endless oceans under cloudless skies. Captain Cook himself of course served during the period of the Seven Year War and saw action. In those days, and even centuries before, warning of attack from the sea was passed across the land by means of beacons, a ring of fire that encircled the coast from the days of the Armada. In peaceful times, beacons were lit as a form of celebration, shown above when a bonfire was built on Beacon Hill at Pickering for the Coronation of King George V.

Staithes Beck

Taken in 1880, it would be unusual to see so many boats so far up the beck today in the spot known locally as Low Coble Gardens, which is the site of allotments. The top house on the right is known as Badger Castle and was the first building erected at the top of Staithes Bank in defiance of the Marquis of Normanby, over which a law suit resulted. This went in favour of the Lord of the Manor. Badger Castle is so named because it was the scene of badger baiting, before William Thompson illegally erected his building on the site.

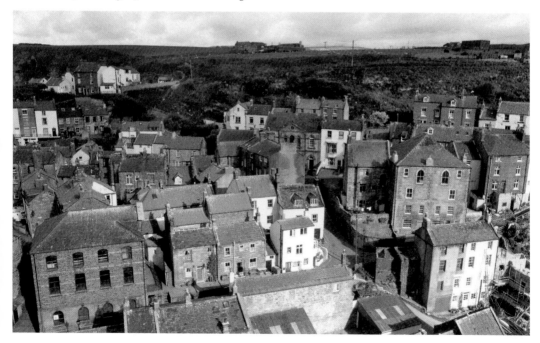

Sanderson's General Store

Photographed in 1927 William Sanderson's shop today is a holiday cottage where at one time James Cook was an apprentice assistant before his days of fame and glory. However, it was not actually this house, but a previous shop nearer the harbour where Cook served. This was damaged over the years by a storm and eventually Sanderson bought this property slightly further from danger and opened up another trading establishment. Cook was bound as an apprentice here from Great Ayton at the age of sixteen. No doubt his brief schooling at Great Ayton helped him get the position; Cook's eagerness to learn arithmetic and writing had already earned him respect among his elders. It was here that James heard tales of the sea and seamanship as customers came and went and his interest in sea and ships developed over the two years he spent in Staithes. It is possible that his employer encouraged the boy's interest. Whatever the reason that prompted his move, in 1746 Cook journeyed down the coast to Whitby where, aged eighteen, he became apprenticed to John and Henry Walker, whose coal vessels piled up and down the East Coast.

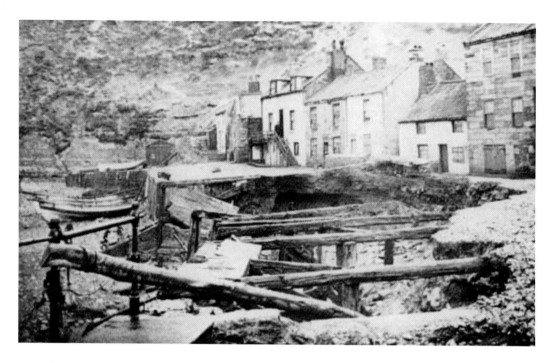

Stormy Weather!

Below, dating from 1908, are the waves coming well up the High Street from the harbour beyond. The waves have clearly dislodged a number of big stones from the road surface. In October 1849 a storm carried away several houses. The above photograph shows the harbour front after a particularly vicious storm and, again, the cottages were lucky to survive unscathed. The memory of Statithes is rich in incidents of the steady encroachment of the sea.

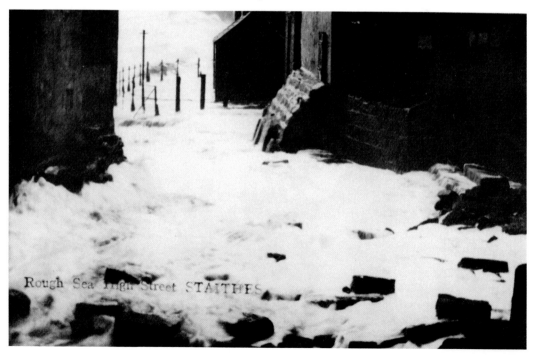

Rough Sea High Street STAITHES

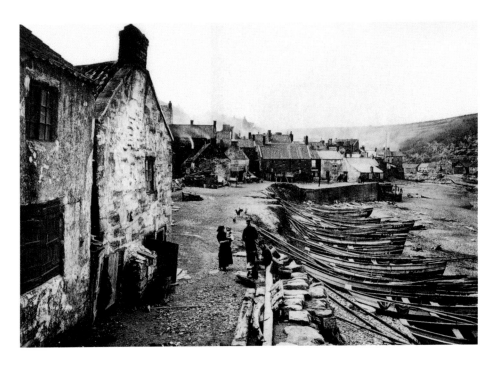

The Harbourside, Staithes

Above, a photograph dating from 1880 by Frank Meadow Sutcliffe shows the fishing cobles lined up against the harbour wall, which at that date was constructed of timber balks driven into the mud and sand. Coastal erosion over the centuries demonstrates why improvements were necessary to the sea defences at a later date. Old Staithes and Cowbar (on the northern bank of the beck) cling to the cliffs like limpets, but over the years, storms and steady erosion have taken their toll, washing away many cottages into the sea, several of which Cook would have known.

Staithes Wesleyan Methodist Chapel

Despite the foundation stone being laid in February 1865, financial difficulties delayed completion of the building and it was not until 1880 that it was finally opened for worship. Today, it is closed for religious purposes and now houses the Staithes Heritage Centre showing scenes of how the village looked in Cook's day. The building with the 'for sale' sign was the original chapel, opened in 1838. Made of local stone fetched from Boulby Quarry, the rear is constructed of red brick. Such building techniques earned the derogatory phrase 'All fur coat and no knickers', meaning lots of show but poor foundations.

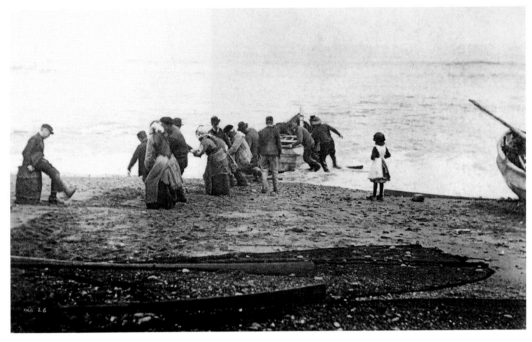

All Hands to the Ropes

Above, Staithes women-folk help their men beach a coble in the 1880s. This was a usual occurrence when most of the male population was away at sea fishing. Today, of course, this would never happen, as most boats if needed to be reached, are hauled out by modern and powerful tractors. Fishing as a tradition still survives despite the many problems fishermen have with quotas and regulations, but it does not carry the same importance in the economy or community as it once did. The boats are no longer the same and rowing and sailing cobles have been replaced with diesel-powered crafts.

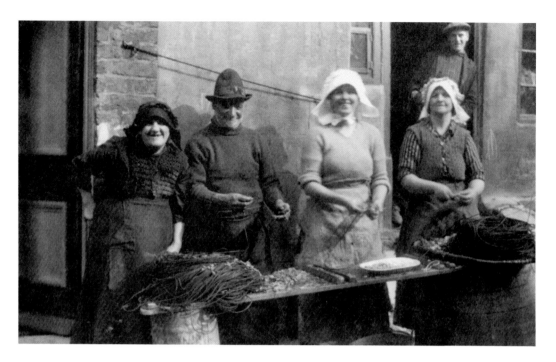

Line Baiting

A happy Thomas Harrison and family, *c.* 1890, are pictured here baiting long lines. We forget what a hard life it was in practice as they struggled to make a living from the sea. Lining was one of the principle methods of catching fish at this date. These are fairly small lines for use by local fishermen – trawlers however, would tow a line perhaps half a mile or more in length that, with branches, could have as many as 15,000 hooks on it. Below is a Frank Meadow Sutcliffe photograph of girls on the beach collecting firewood, as well as mussels and cockles for bait.

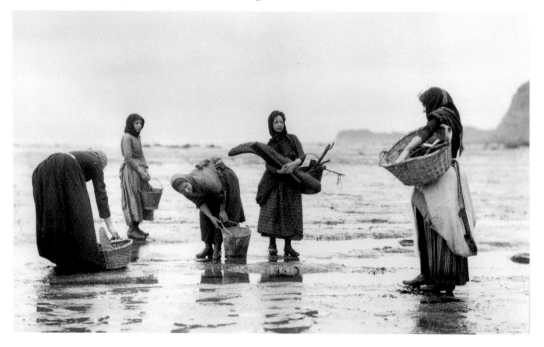

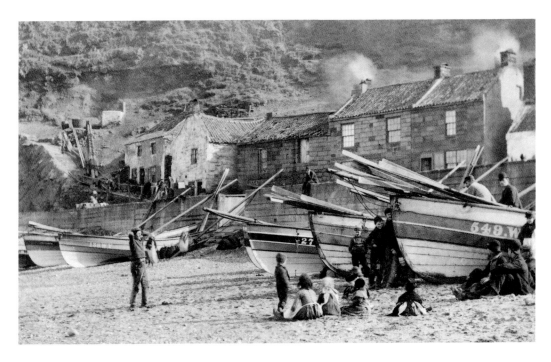

Seaton Garth & Jackdaw Well

Above is a photograph showing bark coppers at the foot of Penny Nab; the site of Jackdaw Well. As a natural spring, it is thought to have stood near to the rear of 'Mizpah Cottage' and the adjoining houses. Here was a natural amphitheatre – an area sheltered by the cliff, which later crashed down and obliterated the site. Up to the early decades of the nineteenth century, the cockpit of the village was situated here, in the midst of the community. Seaton Garth was extensive enough to accommodate a spread of stalls, booths and menageries each year, set up for the Staithes Fair.

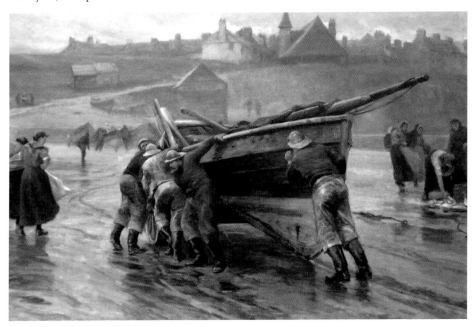

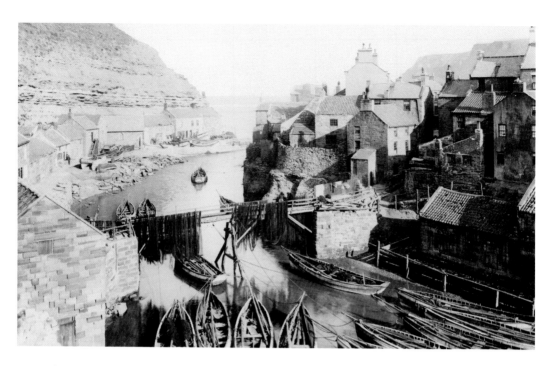

The Fisherman's Friend

A fine collection of traditional coble boats. Over the centuries, the coble has been adapted to cope with various local conditions. A Tudor reference states they have fished as far as 40 miles away from the coast and described them as being 'built of wainscot [and] two men will easily carry it on londe [land] between them'. The coble became the mainstay of the Staithes fleet. The dramatic sweep of the strakes, the shallow draught and the high bow, are all redolent of the Viking longships, which came to these coasts to raid and pillage.

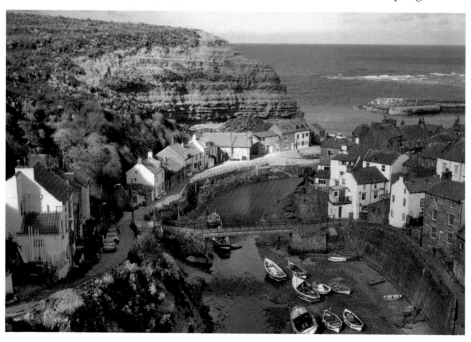

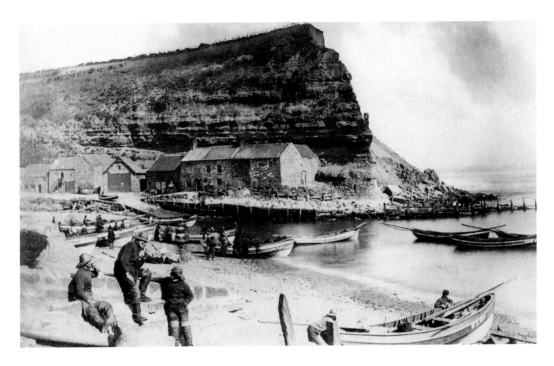

Cowbar Nab 1890

The fishermen here, as at Whitby, enjoy their clay pipes and sou'westers as their popular head gear. Notice the sixteen skips of baited long line alongside the coble in the foreground. Women received 9*d* a line to bait these, including gathering the 'flithers', a name for mussels of limpets. Collecting flithers was back-breaking work mostly carried out by the fishermen's wives and daughters, and the search would take the women as far away as 15 miles from home. When the railway came, local mussels were augmented by supplies from Hamburg, which were delivered regularly to Statihes and carted down the hill at half a penny per sack.

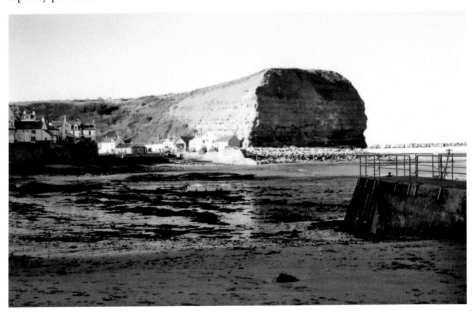

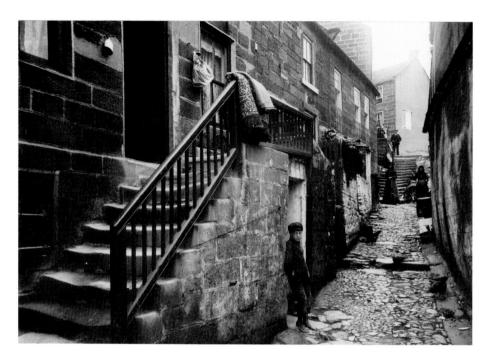

High Barras, Staithes

'Built on a slide between two cliffs, houses jostled and jumbled together as if they would push each other in to the sea – a giant child's box of bricks thrown from the top. Into this chaos of shelter were crowded one thousand souls. The roofs were all tiled or thatched, the walls made of brownish iron stone and here and there was a white washed cottage with green shutters,' commented Dame Laura Knight in 1936 in *Oil Paint and Grease Paint*. Early houses had often been erected using rough stones found on the shore. These constructions, often with earth floors, were known as 'blinks'.

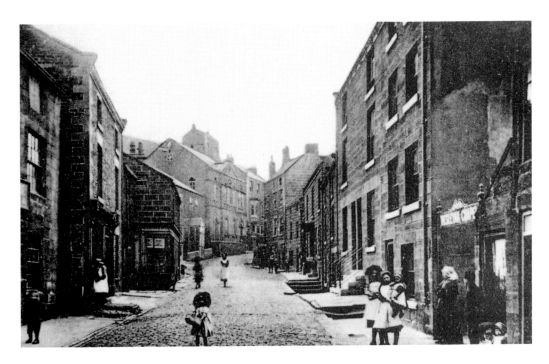

Staithes High Street

Above an old fisher woman keeps a watchful eye on some youngsters playing in the almost empty cobbled High Street. The Bradford-born author, Alfred John Brown, who moved to Sleights, always had a great affection for this sheltered hamlet, which he describes in his book *Striding Through Yorkshire* published in 1938. Below is one of the very few shops still trading in the village. Run by Terry Lawson and his wife Ann, it stocks about everything a person could ask for and more. Terry himself has a wealth of local knowledge and both he and his wife are active members of the community.

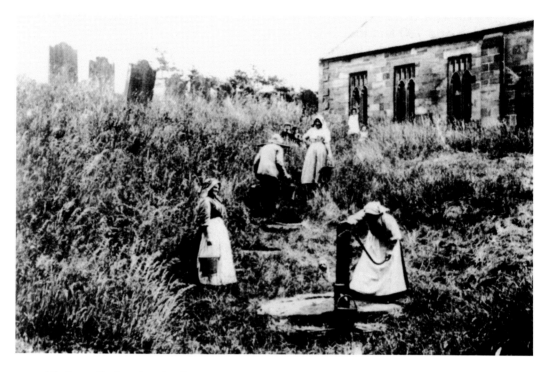

Hinderwell, The Church of St Hilda

Here in the photograph at Hinderwell churchyard at the turn of the twentieth century, we see Mrs Lizzie Hodgson pumping her daily ration of spring water into a bucket. The lady looking on with her bucket is another unrelated 'Mrs Lizzie Hodgson'. The old gentleman carrying the yoke is John Gray, with Mrs Hannah Trattles of 'Gate House' about to pass him. Later, in 1912, the well was refurbished and altered to its present design by Hilda Palmer, Lady of the Manor, who lived at the nearby 'Grinkle Park' (below).

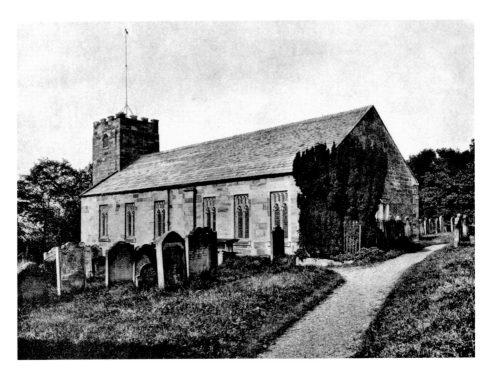

Hinderwell Churchyard & Sanderson Grave

It was the famous well, said to have been created miraculously by St Hilda herself that gave the name to the village. It is possible that James Cook worshipped here as his employer did, who is buried near the east window (below). The inscription in the south face reads: 'To the memory of William Sanderson of Staithes, merchant, who died Nov. 12th 1772 aged 62 years, and his wife who died Dec. – 1813 aged 89 years. Thomas their son died in the East Indies aged – years . Isaac, their son, died Dec. – 1801 aged 30 years.'

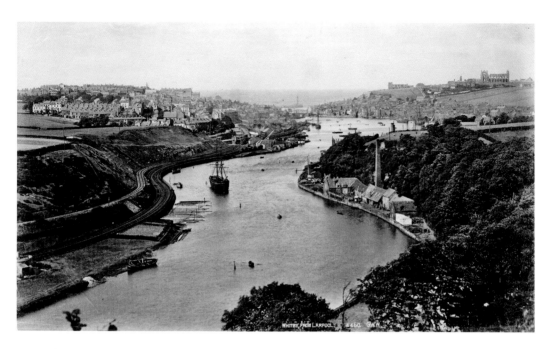

The Esk River & Whitby Harbour

The River Esk empties out into the North Sea, at Whitby, where the estuary widens and shallows. The town is still dominated by the harbour, which today is nothing like the size it was in the eighteenth century when the town was the seventh most important seaport in the country. The harbour now covers approximately 80 acres and the upper marina, opened in 1979, can accommodate more than 200 pleasure craft. The parish church overlooks the harbour and the town below. The slip way is on the site of the old Whitehall shipyard and was the last to cease building ships.

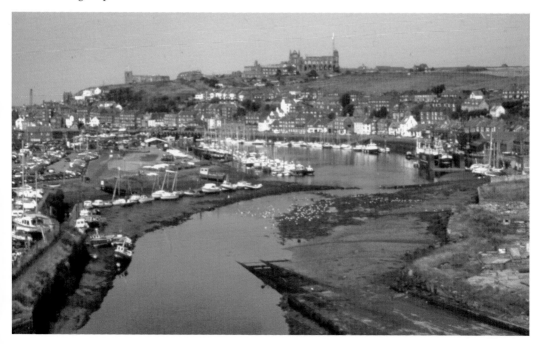

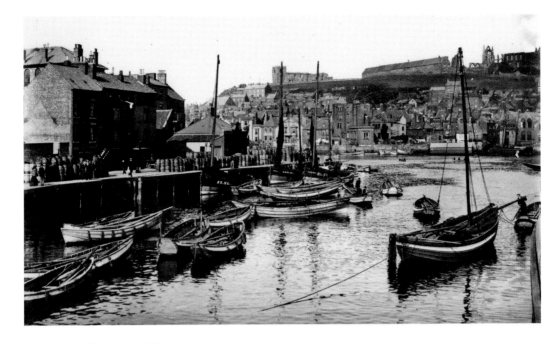

The Start of it All – Whitby

James Cook arrived in Whitby aged eighteen in 1746. His dreams and ambitions of becoming a sailor were about to come true. When he took himself to sea it was to become his home, his life and his consuming passion until his death thirty-three years later. The Walkers specialised in the colliery trade, using locally-built vessels suited to that purpose which sadly were singularly unloved, broad-beamed and bulky, and much given to wallowing, pitching and tossing in any sea short of perfect. However, in time Cook came to appreciate the qualities they had.

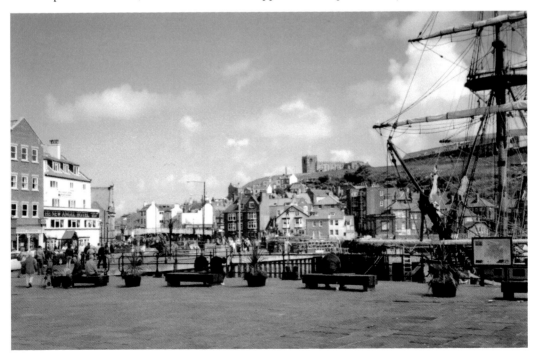

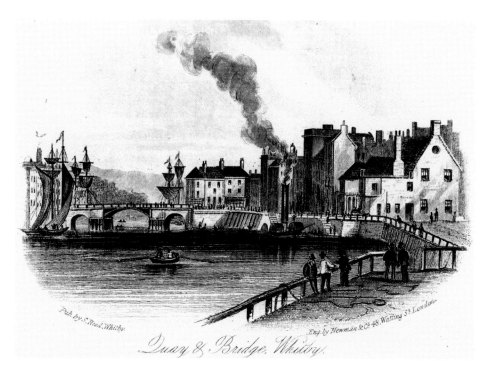

Quay & Bridge, Whitby.

Dirty Old Town, Smoky Old Town

Cook served aboard the *Freelove*, a 450-ton 'cat', as the coal boats were locally known, for his first two seasons, sailing between Newcastle and London. He later transferred to another Walker ship, *Three Brothers*, which extended the limits of his geographical knowledge and seamanship by taking him to the West Coast of England, as well as Ireland and Norway. His apprenticeship over, Cook spent over two years in the Baltic trade, and then he was asked by the Walker brothers to return and become mate of the vessel *Friendship*, an offer which James accepted. Three years later in 1755 he was offered a command, which he declined.

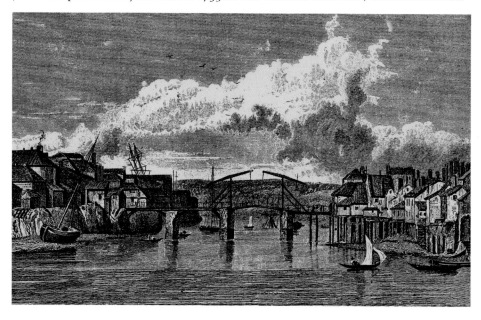

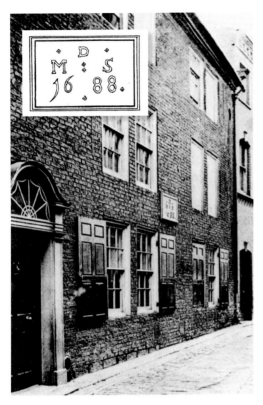

The Walker House, Grape Lane

Cook's employer, Henry, lived on the east side of Whitby along Grape Lane in a house erected in 1688 for Moses and Susannah Dring. Little is known of Cook's professional or personal life during his period in Whitby. Indeed, he does not appear to have had any social life whatsoever; between voyages or when vessels were laid up for the winter Cook devoted himself exclusively to the pursuit of learning. This is one of the few facts of his early life that can be established without difficulty, as the Walker brothers, with whom Cook stayed when not at sea, and their friends were moved to record their astonishment at the long hours Cook spent in improving his knowledge of navigation, astronomy and mathematics. This was a habit it is said that Cook never lost – he kept on learning until he died. Cook's decision to refuse a command with the Walker brothers and join the Navy reveals a fact and raises a question. The fact is that to have been offered a command at the age of twenty-seven, Cook must have impressed the owners with his qualities as a seaman, a navigator and a leader of men, which is perhaps not surprising when one considers the lengths he was going to develop his already marked abilities, including cartography, in the years to come. However, what is surprising is that he passed up the command of a merchant ship from the lowest rank on a naval vessel.

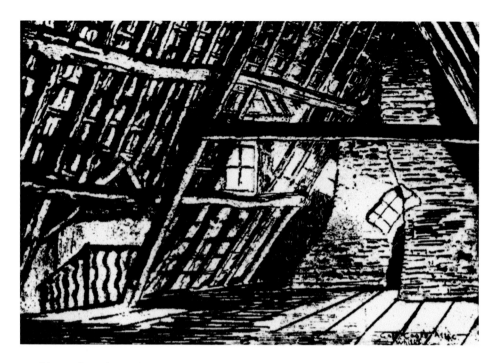

Cook's Study – the Attic, Grape Lane

It was here in this attic at the top of the Walkers' residence that Cook spent much of his life on land between voyages. It was here that he slept with other young lads and it was here that he studied, dreamed his dreams, and planned for the future. As with so many of his decisions, Cook himself offered no explanation for his move from the Merchant Navy to the Royal Navy. Cook was an intensely secretive man, and during his wanderings over the world his officers frequently complained that they never knew where they were going until they got there.

Tin Ghaut

Above, the entrance to Tin Ghaut in 1913 which stands next to the house which Captain James Cook lived and is now the Captain Cook Museum, before its demolition. The photographer's shop was once the Britannia Inn, from which, it was said, the ghaut took its name in the local dialect – t'inn Ghaut. Some say the word *ghaut* is from a Norse term meaning a narrow passage leading to a river. The house that is now the Captain Cook Museum was built for John and Susannah Dring in 1688. In Cook's day it was owned by the Walkers.

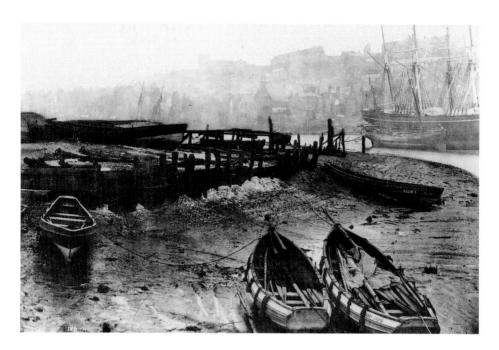

Those Little Ships...

It was at Whitby where the ships were built to assist Captain Cook in his maritime endeavours. Captain James Cook is an iconic figure in naval history, and equably well-known are his three vessels – *Endeavour*, *Resolution* and *Adventure*. Below, an unusual portrayal of the HM bark *Earl of Pembroke* on the stocks of Fishburn's shipyard, photographed above in ruin, in which one can appreciate the stable lines of the craft. Although built as a private contract, it was bought by the navy specifically for travelling to Canada, where Cook was to chart the St Laurence River.

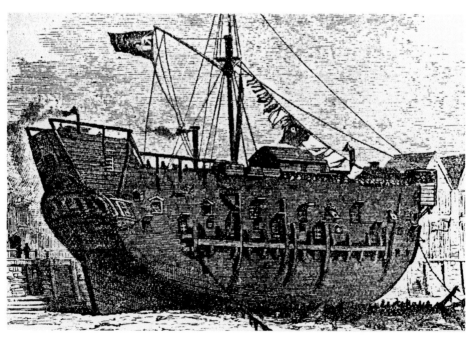

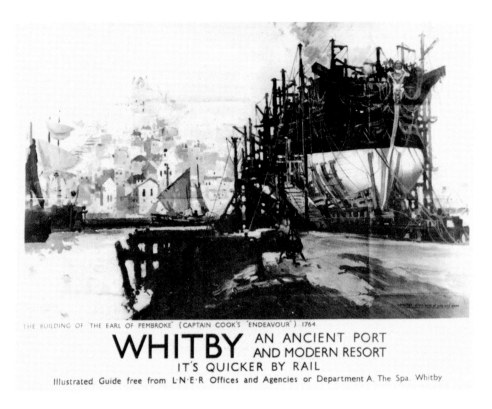

THE BUILDING OF 'THE EARL OF PEMBROKE' (CAPTAIN COOK'S 'ENDEAVOUR') 1764

WHITBY AN ANCIENT PORT AND MODERN RESORT
IT'S QUICKER BY RAIL
Illustrated Guide free from L·N·E·R Offices and Agencies or Department A. The Spa. Whitby

Sing out his Name

Even in 1940 during Britain's darkest hour, when the country was at war, the life of Cook was being exploited. Above, we see a London & North Eastern Railway poster advertising two aspects of Whitby: its antiquity and its emerging status as a holiday resort. The painting by Frank H. Mason depicts his idea of the scene at the building of the ship which was later to become famous as Captain Cook's *Endeavour*. Below, along the harbour side, is a sculpture depicting Whitby's shipbuilding history; two men work on a keel and you can see a tea jug and mugs on the right.

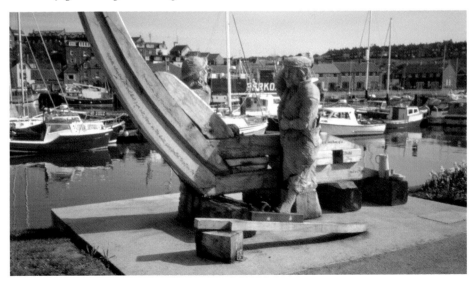

Greengates, Grape Lane

From across the harbour it is easy to spot the tallest building in Whitby, standing on Grape Lane and rising up above its neighbours. Sandgate was first recorded by that name in 1426, also known with Sandgate, which is a continuation of Grape Lane on the other side of Bridge Street, known as the 'Low Streets'. A number of the buildings on Grape Lane were formerly banking houses, which gave it the local name, for a period, of 'Lombard Street', in the satirical literature of the period. In the tall property known as 'Greengates' from the colour gate (see next page) can be found the tallest window in England containing no less than sixty panes of glass, which due to its distinct shape is known as 'bottle window'. A number of other windows of this shape can be found as well, including two of note on Upgang Lane. Bottle windows are a feature of Whitby and were a device to avoid paying window tax. In many parts of England windows were blocked to avoid paying tax, but here in Whitby the legendary meanness of the Yorkshireman came up with the idea of extending the staircase window up the entire length of the building, which only counted as one window, and allowed daylight to light the stairs. Along with Yorkshire sash windows it could save a 'bob or two!' Now in private ownership, it still contains the original safe, which is the size of a room, with its massive door.

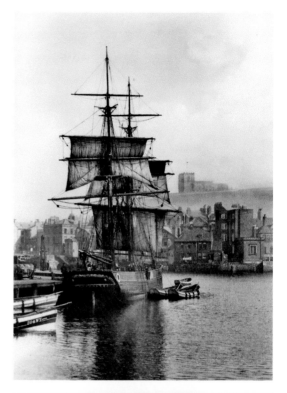

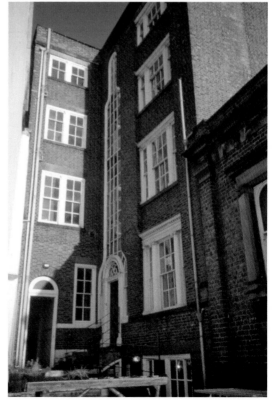

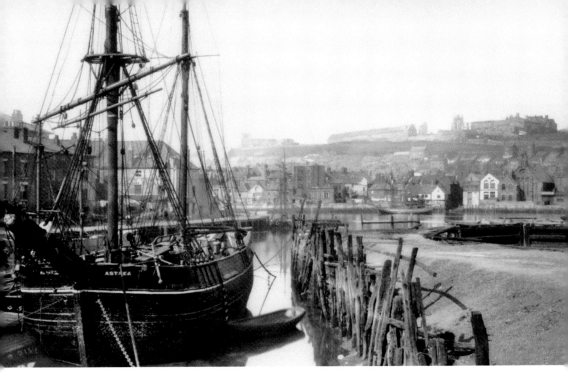

Dock End and Fishburn's Shipyard

Above, Dock End, *c.* 1885, and the remains of the former shipyard of Thomas Fishburn; the rotted stumps were the site of the slipway which saw the last ship to be launched down it in 1862. On entering the Navy, Cook was posted to the fourth rate sixty-gun ship HMS *Eagle* and saw action in the Channel under Captain Hugh Palliser. On 27 October 1757, Cook, now a master, was drafted to HMS *Pembroke*, part of the squadron under Admiral Boscowen, which was drafted to Halifax, Nova Scotia, in April 1758. Below, the *Earl of Pembroke* leaves Whitby.

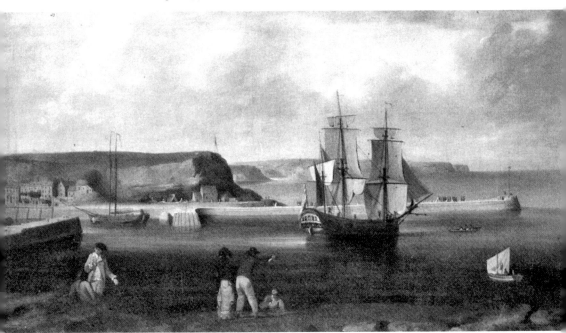

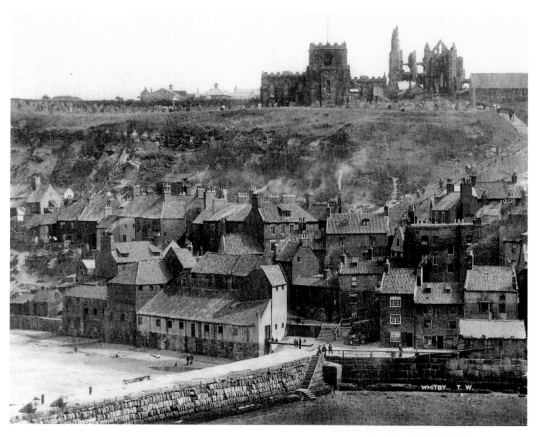

Sail Away Me Hearties!

A view of east Whitby from Spion Kop in 1892; Tate Hill pier and Tate Hill sands are in the foreground with the densely populated rookery of Tate Hill behind. The large building on the sands, to the immediate left of the pier, was Sander's sail-cloth factory, founded in 1756. It was in this factory that the sails were made for Captain Cook's ship *Endeavour*, and, indeed, for most of the whaling fleet. Today, the scene is a complete contrast and many of the buildings have disappeared leaving terraces reaching up from the sands almost to the cliff top.

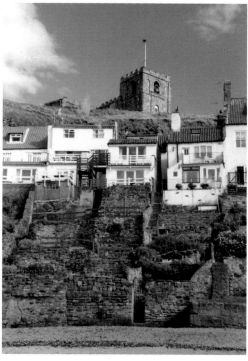

The Ropery

The Ropery in 1938, which gave its name to the street, the Ropery. It was first erected in 1721 and was 440 yards long. A second ropery (below) stood at Spital Bridge, alongside Spital Beck until recently. In its time the beck was used to soak wood prior to bending. A third ropery is known to have stood at the end of the old Skinner Street, which is said to have been cut through when the road was extended. It can be traced in Young's jewellers and what was the old launderette building straight across from it, which has been replaced by a brick holiday cottage on the same foundations.

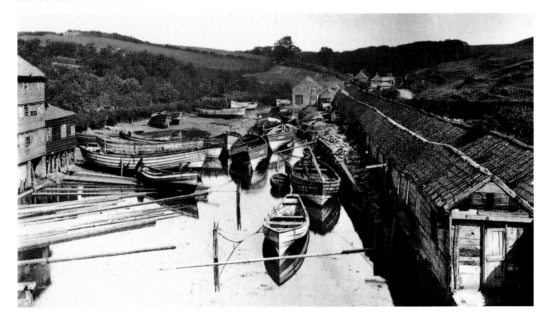

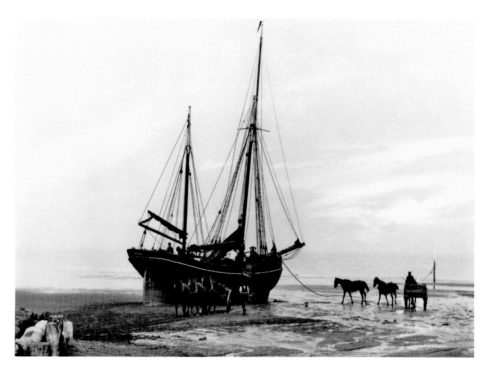

Ship Ahoy!

Unloading coal directly from the boats was a common practice before the coming of iron steam ships and, as a consequence, locally-built vessels, called 'cats', had a flat bottom for beaching. The *Diamond* was owned by Captain William McLean of Sandsend and carried coal from either Blyth or Hartlepool. Here it is seen on Sandsend Beach. About this time, in 1887, best household coals cost 14s per ton. Today, constant dredging of the harbour allows for vessels to moor up to a quay and off-load conventionally straight onto dry land. Below can be seen the latest of the Whitby dredgers.

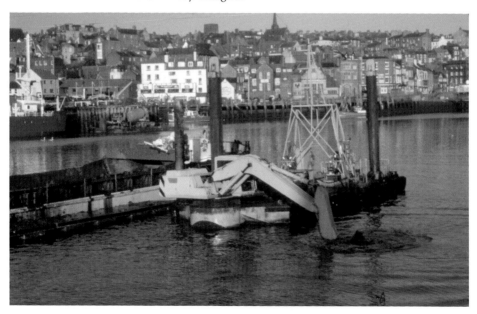

Ships in the Harbour

Taken on 19 September 1895 by Frank Meadow Sutcliffe, this photograph shows the vessel *Anne* in the upper harbour framed by the entrance to the North Eastern Railway Company's town station. While I can't remember when I took this photograph of the Australian-built replica of Captain Cook's famous *Endeavour* from the same position. As you can see the dock end has been filled in and covered by the ubiquitous motor car, highlighting the reduced significance of the harbour. The station was opened before a large assembly of people with due pomp and ceremony – a band played and a suitable poetic eulogy was prepared, which read:

> When Whitby's wealth in yearly
> steps decay'd,
> By Stephenson's bold schemes her
> fall was stay'd;
> And now, behold! The works his
> labours won
> On wings of steam bring here his
> far fam'd son,
> Whose powerful genius and
> inventive mind
> Shall show us all how best our
> local wealth to find.
>
> Hail! To the man whose well
> carried fame
> Through [all] the wide world is
> know;
> Happy the day! When Whitby's
> sons
> May claim him as their own

The Seaman's Hospital, Church Street

The Seaman's Hospital was founded in 1675 to assist distressed seamen, and to provide relief for their widows, and the education of their children. The present building was established on its site in the eighteenth century, but the façade dates only from 1842 and was built to a design by Sir George Gilbert Scott. In 1995, there was extensive exterior restoration and remodelling of the interior. This also led to the replacement of the figure in the central niche in fibreglass, a copy of the original figurehead from the boat *Black Prince*. Behind this noble exterior lay three yards. In 1702 and subsequent years, Acts of Parliament provided funds by way of a duty of one halfpenny per Newcastle chaldron on all coals shipped at Newcastle, Sunderland, and other parts of the north passing to the south, as Whitby was viewed as a harbour of refuge for collier boats. Duties on coal, salt, and corn, etc., were also imposed on goods landed at Whitby, together with butter and fish shipped, and on ships entering the port. The revenues from this Act averaged from £3,500 to £4,000 per annum, a portion of which went toward the maintenance of the almshouse. A further 6*d* per month was levied on all serving seamen and paid to the almshouses and Muster Rolls were kept of the sailors and their travels including those for Cook's voyages.

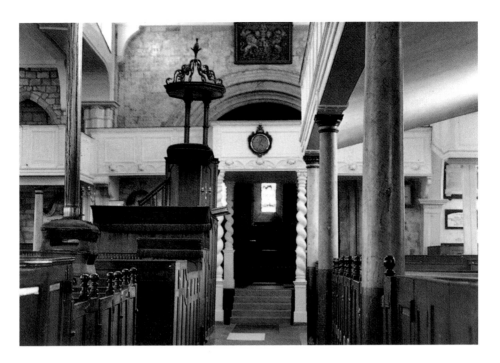

St Mary's Parish Church, Whitby

Acceptance of a home in the almshouse meant compulsory church attendance, and, indeed, for most sailors in home port on Sunday this was their custom too. It didn't mean, however, that they had to like it and pay attention. Often as the sermons droned on for great lengths, the bored seamen would take out a pocket knife and make a carving on the backs of the pews. Today, many survive and below are just a few of the one hundred plus images to be found cut into the woodwork – (A) a sloop, the hull with gun ports; (B) another sloop; (C) a sloop with Union Jack.

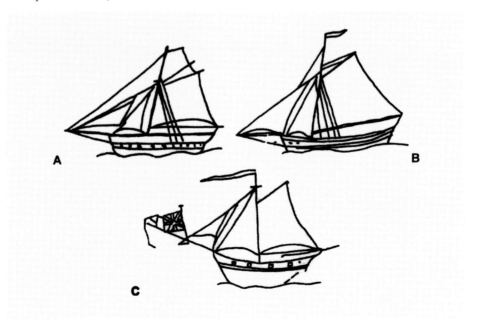

The Piers – A Safe Haven

The earliest mention of the harbour at
Whitby occurs in 1307, when King
Edward I made a grant towards a quay
'... newly to be constructed at Whitby'.
In 1341, a grant of quayage was made by
King Edward III to 'the bailiffs of the town
of Whiteby', for seven years, to repair
and amend the quay which was 'already
decayed and broken down by force of the
sea'. The piers were first built of stone
around 1540. This work was carried out
at the command of King Henry VIII, who
ordered any maintenance thereafter to be
at the Royal expense. In 1632, the present
stone structures were begun. The violence
of the sea, however, soon necessitated
repairs, and the piers were again repaired
and much improved under the direction
of the Cholmley family in 1660. By 1696, it
was said that Whitby harbour was one of
the 'commodius ... in the north of England,
being capable of receiving 500 sail of ships
[that might] go out or in with any wind
[and was] a great nursery of seamen [but]
the ancient piers [were] much decayed [and]
the mouth of the harbour was choked up,
and in danger of being quite stopped up
... to the great prejudice of the trade of the
town and navigation.' In 1702 they were
repaired again and again in 1734, 1814
and 1831. Finally, in 1912, the two outer
extensions of wood on concrete foundations
were added.

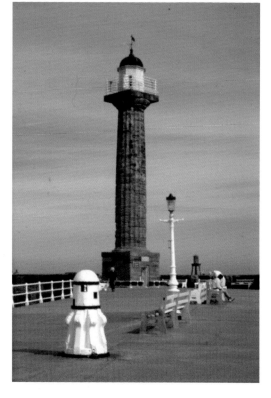

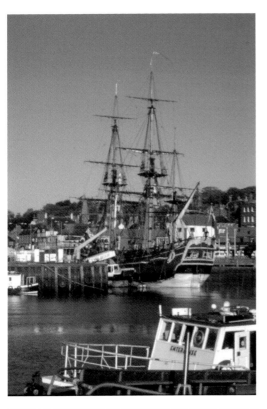

The *Endeavour* Project

His Majesty's Bark *Endeavour* left Plymouth at 2 o'clock in the afternoon of 26 August 1768 with a complement on board of ninety-four officers, scientists and men. There were also two greyhounds and a goat, ammunition, provisions and stores for the voyage, almost bursting to the seams. She returned in 1771, having passed Cape Horn in January 1769, and then crossed the Pacific via Pitcairn Island and Tahiti to New Zealand. The ship then sailed up the East Coast of Australia, past Java, across to Cape Town, up the West Coast of Africa, St Helena, Ascension, and in past the Azores to England. She had been reported missing, probably lost, but the battered old Whitby-built collier with pennants flying and the great ensign of the King's Navy above the quarter deck sailed up the Channel and anchored off the Downs. It was Saturday 13 July 1771. There were fifty-six men and boys aboard of the ninety-four who left England almost three years earlier, plus the indestructible goat. The *Endeavour* must have been quite a ship. With this in mind it was proposed in 1977 that a full-size sailing replica should be built at Whitby as 'a memorial to James Cook as living proof of Whitby's maritime history'. To that end a registered charity was set up, money sought to finance the project and permission from Scarborough Borough Council (SBC) to use the old Whitehall Shipyard and slipway to set up a museum and workshops. Sadly, SBC had little faith in the project at a time when employment was high and the project would have been a boost to the economy. As a result of SBC's decision, Australia took up the challenge.

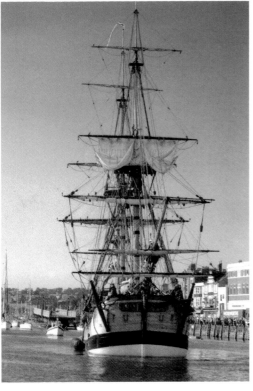

TO COMMEMORATE THE 200th
ANNIVERSARY OF THE LANDING
CAPT. JAMES COOK R.N. F.R.S. AT
NOOTKA SOUND, BRITISH COLUMBIA,
CANADA MARCH 1778 UNVEILED BY
THE AGENT GENERAL FOR BRITISH
COLUMBIA, L. J. WALLACE, O.C. LL.D.
OCTOBER 1st 1978

CAPTAIN JAMES COOK, R.N.
1728–1779
EXPLORER OF THE
AUSTRALIAN EAST COAST
AND OF THE
ISLANDS OF NEW ZEALAND

Lest We Forget

The statue of Captain Cook seen below shows it before the new landscaping of the West Cliff and the area around whalebone arch and Cook statue. Then, as can be seen, the statue rose from a flower bed, and at each cardinal point plaques were placed at the statue's base over successive years (above). Whitby makes a tremendous show of venerating Cook and his achievements, playing on his connections, so it was sad to see that when the site was newly laid out the plaques and plinths had disappeared, and some can now be found tucked away behind Trinity Church, hardly noticed!

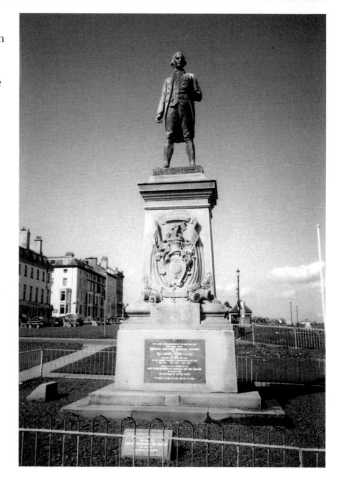

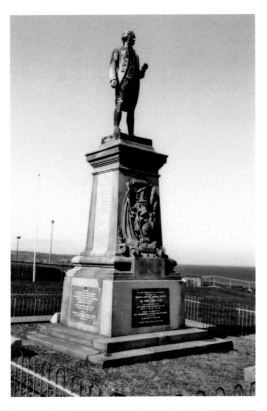

James Cook (1728–79)

Old Staithes introduced James Cook to the restless sea and world of ships. He was apprenticed to William Sanderson, grocer and haberdasher, whose double-fronted shop stood on the seafront, close to the harbour – so close, indeed, that sheets of spray from gale-tossed waves might sweep right over. The premises were pounded into instability and the business had to be transferred to the cottage in Church Street. This occurred in 1812, when Cook had long been dead. In his time the interior of the shop was a jumble of boxes and sacks and lengths of cloth between which he had to bed down at nights. In his brief spare time he could clamber to the head of the cliff, watching ships sailing on a busy East Coast route. At this time, shipbuilding was undertaken at Staithes and this stretch of coastline was used by smugglers, and preventative officers kept watch on seaborne traffic. A writer in 1978 claimed, without written evidence, that Cook was for a time engaged in smuggling, but it seems unlikely. Sanderson was a religious man, a warden of the church at Hinderwell, where doubtless James Cook accompanied him to the Sunday services. When Cook's three-year term of apprenticeship was over, Sanderson took him to Whitby and introduced him to the Walker family, ship-owners, in whose employment he learnt seamanship.

Cook's Statue – West Cliff

The statue of James Cook overlooking
Whitby harbour shows him as the navigator
holding in his hands the instruments of the
trade he learnt at Whitby. The 20-foot high
plinth of local stone bears a carving of one
of the Whitby-built ships which carried him
on his voyages to the South Seas. It also
bears a copy of the coat of arms awarded to
his family by George III which in graphic
terms of heraldry proudly proclaims his
achievement: the shield displays a map of
the Pacific Ocean and around is the motto
'Circa orbem nil intentatum reliquit'. The
bronze statue of James Cook, 7 feet 6 inches
high, is the work of John Tweedy, sculptor,
and was and was presented to the town
by Gervase Beckett MP, and unveiled on
12 October 1912. Another face carried the
inscription:

> For the lasting memory of a great
> Yorkshire seaman this bronze has
> been cast and is left in the keeping of
> Whitby the birthplace of those good
> ships that bore him on his enterprises
> brought glory and left him at rest.

The plinth also carries four bronze plaques
on each side. One given by the people of
New Zealand dated 2 April 1984; one given
by the people of Canada on the 250th
anniversary of his birth in 1978; one given
by Australia on 20 April 1970; and a fourth
plaque is to commemorate the men who
built the Whitby ships and is dated 26 April
1968, the bicentenary of his first voyage.

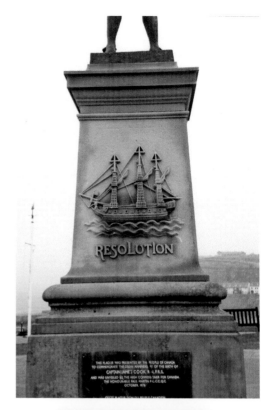

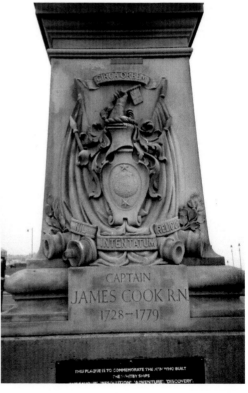

Careening

An unusual task, performed at low tide on the sands during the eighteenth century, which may well have been witnessed by a young James Cook. The photograph below shows the same method being used in the 1960s. The artist's viewpoint in the print appears to have been observed from the shipyard of Thomas Fishburn and shows the slipway and primitive docking facilities used in the eighteenth century. Careening was the act of scraping off the barnacles and seaweed that encrusted the ship's hull, which in time, if not taken care of, would affect the ship's sailing ability.

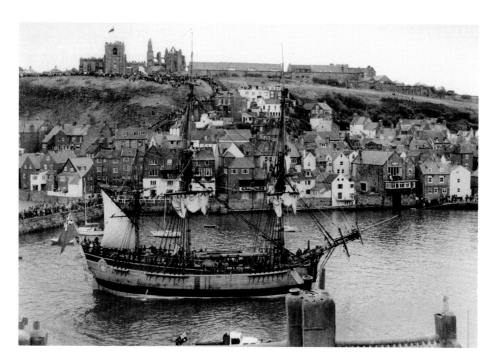

The Homecoming & the Leaving!

In May 1997, the Australian replica of the *Endeavour,* as part of a worldwide tour of places associated with James Cook, made its first visit to Whitby. Despite the fact that the initial idea of a replica ship was proposed by Whitby, there was no bitterness, and its homecoming was a success. The ship was greeted by a rapturous multitude who lined the harbourside and cliff tops to gain sight of the vessel as it came into Whitby harbour. I remember having a harbourside view standing next to my wife and parents who had come over from the West Riding especially for the event.

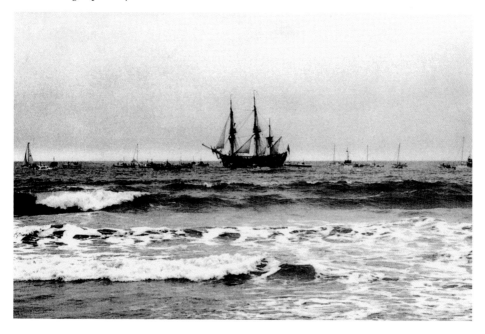

Seen One *Endeavour*, Seen Them All!

In 2003, Middlesbrough staged their own Captain Cook event. The centre piece of this celebration was a steel-hulled replica of the *Endeavour* which was to be sited permanently on the quayside at Stockton on the River Tees. Stockton features on the Captain Cook Trail as it was once a bustling port from which coals and other goods would have been picked up by colliers from Whitby and shipped to London and Bristol, and undoubtedly James Cook visited here. I recall going to a family party and being introduced to Peter Manuel, who was working on the replica and later gave me the picture below.

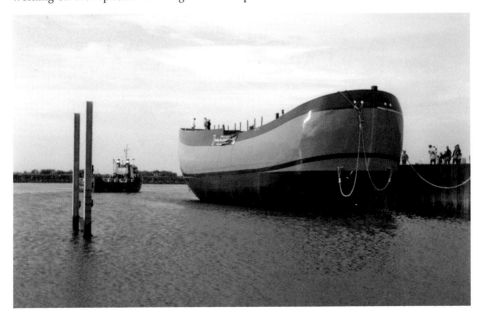

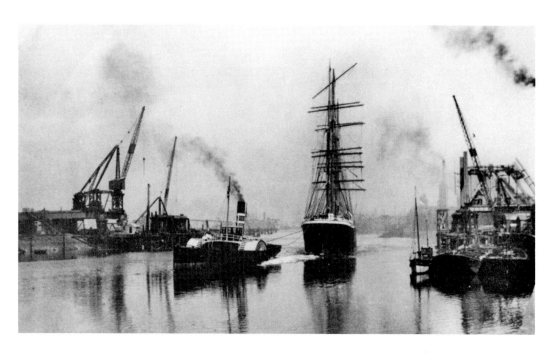

Corporation Quay, Stockton-on-Tees

Above, the early stages in the construction of the Newport Bridge are evident as the paddle tug *Cleveland* tows the SS *Winterhude* upstream to the Corporation Quay, Stockton, June 1932. The tall ship had struck the span of the Transporter Bridge on its way upriver, causing visible damage to the top of the mainmast. Below, believed to date from about 1870, this early photograph shows a sailing ship moored at the Bishop's Landing Place on the quayside in Stockton. The Baltic Tavern can be seen beyond the stern of the ship. Heavy sacks are being transferred between the small barge and the ship.

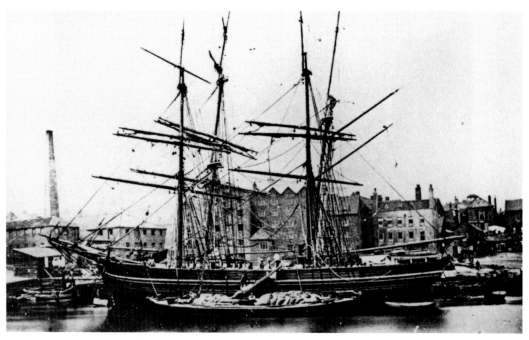

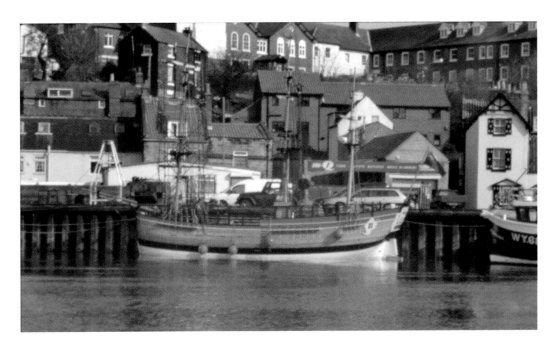

Tourism & the *Endeavour*

There is no doubt about it; the *Endeavour* captures the imagination of anyone with a modicum of interest in Captain Cook and Britain's maritime history. So it was inevitable that the town should have its very own replica, even if it is only half size. Today, if it wasn't for the Abbey and St Mary's church on the headland, this modern marina (below) could be anywhere on the Mediterranean coastline, with its crystal clear sunny skies, and still waters reflecting yachts and fringed by acres of newly-built apartments overlooking the harbour. Tourism is now the face of Whitby.

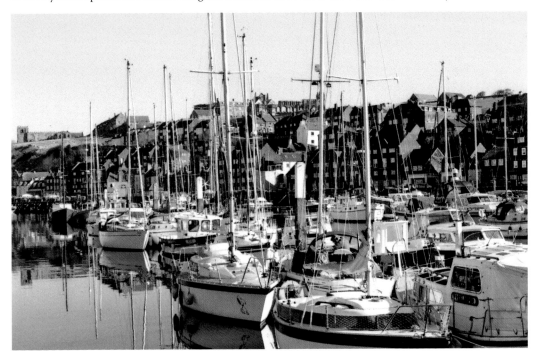

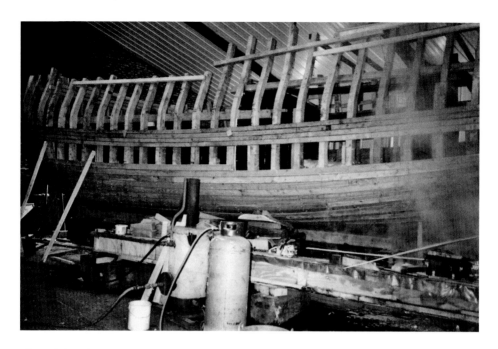

The Mini *Endeavour*

'A small scale *Endeavour* replica was built at Parkol Marine. Engineers at the boatbuilding firm are busy constructing the vessel – 40 per cent the size of the Australian replica – to be used as a pleasure boat for Colin and Rachael Jenkinson. Unique building techniques are being brought back to life to recreate the splendour of the *Endeavour*. Jim Morrison, a partner at Parkol, said the company hoped to have all the planks in by Christmas (2001) ...' The Jenkinson family had for generations been involved in fishing, but the loss of that industry to the town brought about their diversification into tourism.

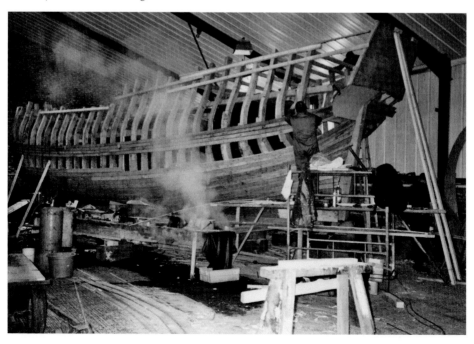

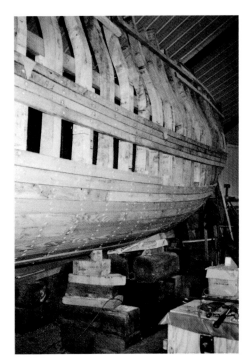 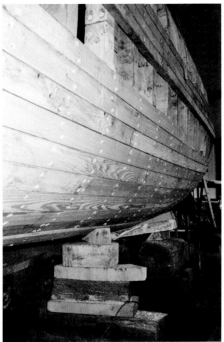

A Maritime Heritage

The photographs of the construction of the mini *Endeavour* show that the skills of past generations are still in existence – but for how much longer? These skills are part of Whitby's maritime heritage and should be encouraged. Part of the town's maritime heritage is also to be found in the splendid Georgian houses along St Hilda's Terrace (below). As the ship-owners and builders got richer, they moved out of the rapidly declining heart of Whitby and set up new homes in the clearer and higher grounds of the town. Another interesting relic of those days – a ship's architectural model – can be found attached to a garden gate.

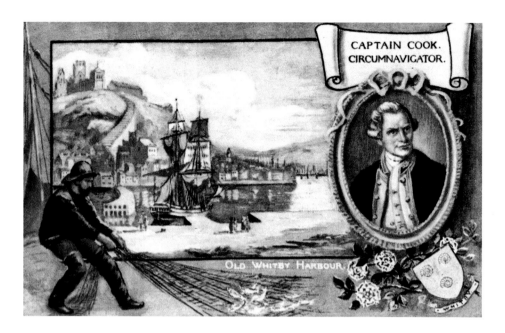

CAPTAIN COOK.
CIRCUMNAVIGATOR.

OLD WHITBY HARBOUR.

Captain Cook through the Eyes of the Artist

Above, an interesting postcard from the local firm of printers long since gone, Abbey Press of Grape Lane, showing past scenes of Whitby. If somewhat fanciful, it captures the spirit of the place and some to its main points like the 199 steps, Abbey and church, and harbourside. Below, the 'Vikings of Whitby' as seen through the eye of George du Maurier in this cartoon that appeared in the nineteenth-century *Punch* magazine. Du Maurier and his family were among the many regular famous and talented visitors to the town and were inspired by its environs.

The Church of St Mary, Barking

Cook was an extremely shy man, and as a consequence, we have little knowledge of his personal life. Of his marriage, all we know is that he returned to England in November 1762, and on 1 December of that year he married Elizabeth Batts, a 'spinster never married', in St Mary's church, Barking, his bride's parish. It is not known where or how they met, anything of their courtship, or whether it was a happy or a sad relationship. They did produce children in the short time they spent together during Cook's voyages, and his wife outlived him.

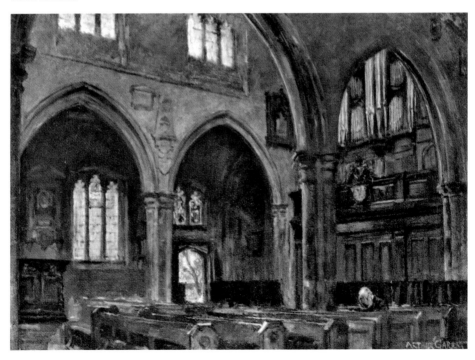

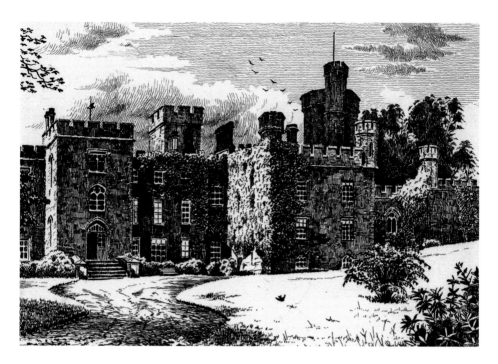

Early Admirers of Captain Cook

The bravery and deeds of James Cook and his boats and men who three times circumnavigated the globe, was a great inspiration to many, and attracted many admirers. The Whitby merchant John Campion was quick to erect a memorial to Cook's memory on Easby Moor soon after his death. Another admirer was Constantine Phipps, 3rd Marquis of Mulgrave, who lived on the outskirts of Whitby at Mulgrave Castle. He immediately set about collecting published works, documents and private letters about Captain Cook and amassed a great collection before he died in 1932.

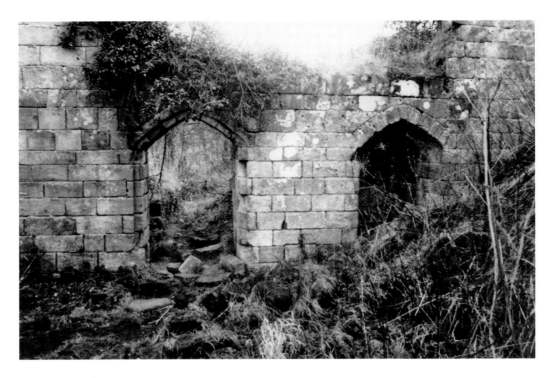

Mulgrave Castle

The present Mulgrave Castle dates to around 1735 when John Schofield was created Duke of Buckingham in 1703 and was erected as a fitting countryside mansion for his wife. The original castle remains, above, are in the grounds of Mulgrave Wood, but rather than rebuild the old structure he chose a new site on rising ground. When the 4th Earl died all the titles became extinct and the estates went to the Crown, who leased them to Constantine Phipps, a grandson of the Duchess of Buckingham, and they have remained in that family since.

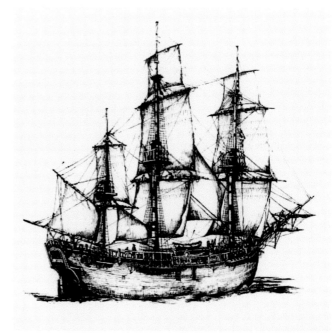

His Majesty's Bark *Endeavour*
The *Endeavour* was no great windjammer with acres of sails to speed her over the oceans. She was just 109 feet long, 29 feet 3 inches broad, with a draft of 12 feet 6 inches. Internally, she was 97 feet 7 inches on the lower deck with a keel of 81 feet and a depth in the hold of 11 feet 4 inches. The oak keel, was the base of the ship, 18 inches by 18 inches, made up of four lengths scarfed together making up a total length of 81 feet. Her oak planking was bent onto oak ribs. Her masts were made of Scandinavian spruce and pine, the main mast rising 114 feet 3 inches above deck and made in three sections.

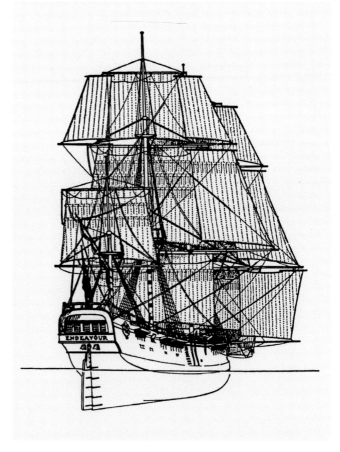

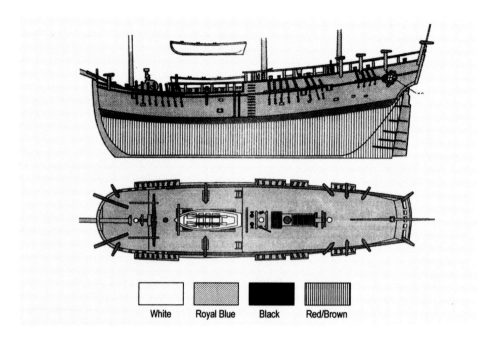

White Royal Blue Black Red/Brown

Boys' Toys!

Model making has always been a popular occupation, particularly for boys, and in the world of model making the name Airfix is synonymous. Airfix have produced models of practically everything and I remember building models of Roman soldiers, cavalry officers on horseback, First World War and Second World War infantrymen, and aeroplanes of every description. However, one of my biggest challenges was the construction of HM Bark *Endeavour* of which I still have the instruction booklet; the colour drawings seen above are reproduced from this booklet. It is also possible to appreciate the lines of the vessel from these drawings better than in a colour photograph.

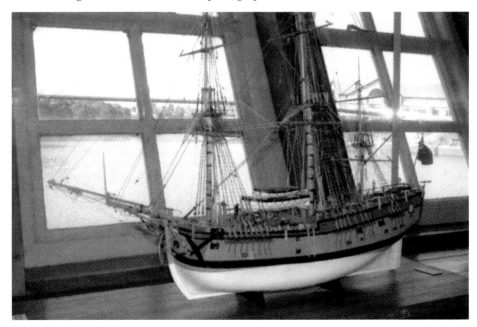

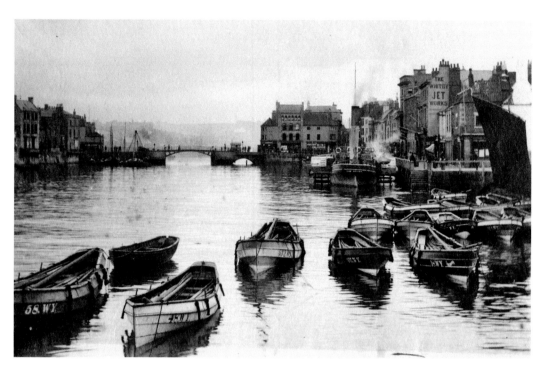

The Coble Boats in Whitby Harbour

A collection of fishing cobles (pronounced cobbles) can be seen here in Whitby harbour sometime in the nineteenth century. Their traditional seaworthy design dates from the Viking period. The deep bow and flat bottom stern with a steep end rake also made them ideal for launching on open beaches. Cobles with a sail and a sharper stern were known as mules. Today, of course, most cobles are powered by inboard motors. In the background the old drawbridge can be seen.

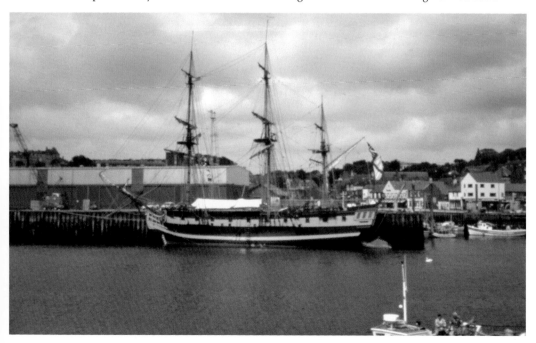

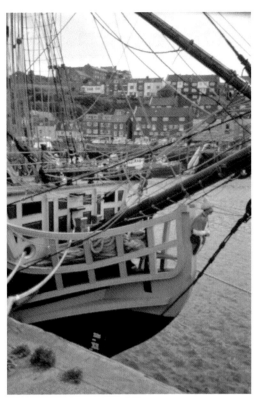

The *Grand Turk*

The success of the visit of the *Endeavour* prompted others to emulate and for a period of a few years Whitby was visited by the *Grand Turk*, a replica of an eighteenth-century British fighting frigate. Similar ships were built in large numbers at Whitby. The replica frigate is 119 feet long, 34 feet wide, with 12 cannon, three 100 foot masts, 22 working sails made of rot-proof canvas and 3 miles of rope for rigging. A crew of twenty-six was commissioned by ITV for the *Hornblower* series starring Robert Lindsay. The ship was the first of its type to be built for more than 150 years. It was built in Marmaris, Turkey, where one day I drove past a shipyard and noticed a wooden vessel being built in the traditional manner and never gave it a thought nor took any photographs! Little did I realise I would meet her again at home. Two hundred hardwood trees were used in the construction of the ship. She cost £2 million and was built at the expense of Michael Turk. She was later named the *Grand Turk* in August 1997 and was only completed one month behind schedule. After it served its purpose in the filming of *Hornblower*, the Turk family used it for charter hire and private and corporate functions, and then they brought it to Whitby where it stayed. In May 2007, it was put up for sale at a cost of £3 million.

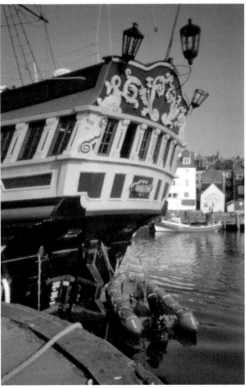

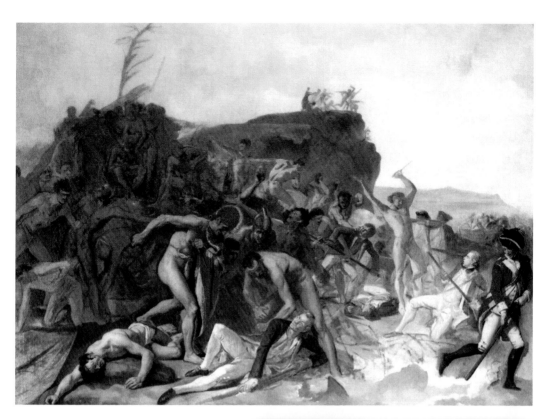

After Death Comes Life!

Above, the unfinished painting, *The Death of Cook*, by Johann Zoffany (1734/35–1810). Zoffany was a portrait painter who is best remembered 'for his "conversation pieces" crowded with figures, lively in spirit, and highly skilled in the painting of detail. His paintings are valuable to historians and antiquarians as records of features and costume ...' so states the *Oxford Companion of Art*. Below, a painting of Elizabeth Cook in old age, who, at this time of her life, probably best enjoyed the fame of her late husband.

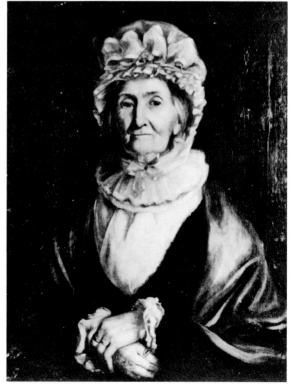

In 1775, on his return from his second voyage, the Royal
Society awarded Cook the Copley Gold Medal

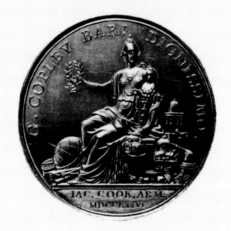

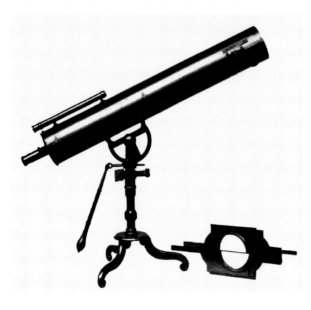

The Copley Gold Medal

In 1775, on his return from his second voyage, the Royal Society awarded Cook the Copley Gold Medal. Cook's first voyage was to command a vessel that was to transport members of the Royal Society to observe the Transit of Venus – that is, the passage of Venus between the sun and the earth, which was to take place on 3 June 1769. The astronomers were members of the even then prestigious Royal Society. There had been a previous Transit of Venus in 1762, but the observations achieved had ranged from unsatisfactory to useless. This observation that the Royal Society now hoped to make, was expected to be of the greatest value in the advance of astronomical navigation. The part of scientists were under the leadership of Joseph Banks who later became the president of the Royal Society, a post he held for almost half a century, during which time he was the undisputed ruler of the scientific world in Britain. Along with Banks was Dr Carl Solander, a Swede and a famous botanist; Alexander Buchan, a landscape artist; Sydney Parkinson, an artist who was to make pictorial recordings of all the fauna they caught; Sporing, who was loosely defined as a scientific secretary; and four servants. Lastly, came the Royal Society's official astronomer, Charles Green, who was to share with Cook the responsibility for the actually observation of the transit using the telescope shown.

The Scoresby Family

Perhaps more closely allied with Whitby and its maritime history than James Cook, are the two famous whaling Captains, William Scoresby, senior (1760–1829) and his son, William Scoresby, junior (1789–1857). These two are commemorated in the Scoresby Memorial unveiled on Wednesday 20 April 1996, which stands at Dock End. It is 30 feet high and is in the form of a crow's nest mounted on a mast, which Scoresby senior invented, with two figures representing the Scoresby's. It was designed by Hull artist Kevin Storch and the crow's nest was constructed by Kevin Richard Limbrick of 3P Designs in Scarborough, who provided the materials free of charge. Forest Enterprise donated the mast, also free of charge. The sculptured figures, however, cost £15,000, which was paid for by the Whitby Tourism Renewal Scheme and by donations from businesses and individuals. Sadly, however, at its unveiling it was found to have a serious error. The artist had depicted one figure with a pair of binoculars; unfortunately, these did not exist at the time of Scoresby and, as a consequence, the sculpture had to be taken down and the artist simply chiselled away the offending item, which is why the figure (bottom left) now appears to be clutching his overcoat! Interestingly, as I sit and write this page, I read in the local newspaper that the Scoresby Memorial was blown down today in the severe weather on 4 April 2012 – an amazing coincidence!

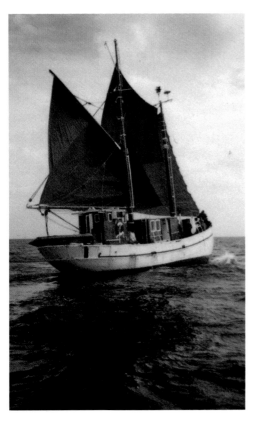

The *Helga Maria*

Built in Esbjerg, Denmark, in 1929, the boat is a two-masted schooner and was first named *Argus*. It was constructed for fishing skipper Soren Christensen, but in 1938 a half share was taken by Christensen's brother Laurits. He continued as master until 1978, when the vessel was purchased by Terkel Nyborg, who promptly sold her to an English firm named the 'Angus Fishing Company', Grimsby. Here the boat arrived complete with a new engine on 27 January 1978. From this date, she was renamed the *Helga Maria* after the mother of the skipper. On St Valentine's Day 1984, Whitby sailor Jack Lammiman purchased it from Grimsby. Jack, a sailor since the age of sixteen, was passionate about the Scoresby's maritime feats. In 1991 Jack sailed the *Helga Maria* to the Arctic Circle in the wake of William Scoresby. Inspired by the exploits of the voyage, a film was made entitled *Captain Jack*. Described as a 'highly enjoyable comedy', it was written by British TV scriptwriter Jack Rosenthal and is based on the book of Lammiman's voyages entitled *Helga Maria* by Edna Whelan. Bob Hoskins played Lammiman and it co-starred Maureen Lipman and Michele Dotrice. The boat starred as itself, but was renamed *Yorkshire Beauty* for the film. It premiered at the London Film Festival in November 1998 and then at Whitby Pavilion Theatre to a sell-out audience of 450. It went on general release in Odeon Cinemas at the end of May that year.

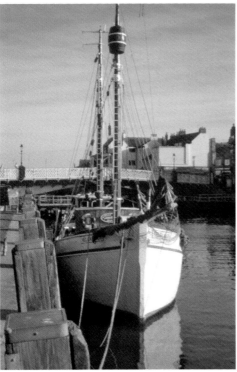

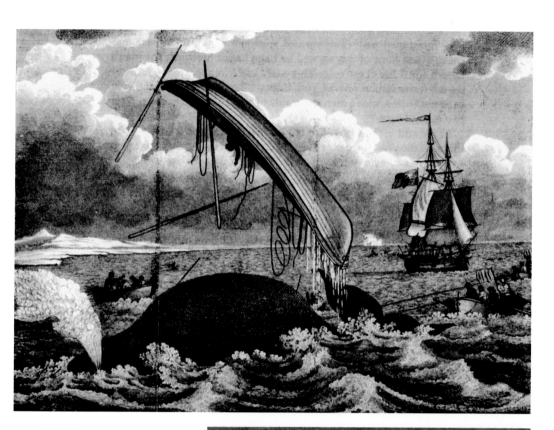

Whaling

Whitby's whaling industry began in 1753, when two small ships were fitted out to hunt for whales in the Greenland Sea. By the late 1780s, Whitby was equipping as many as twenty ships for whaling and had gained a reputation as a major whaling port. Whale hunting in the Arctic was full of danger and hardship for the ship's crew, but a 'full' ship brought prosperity to both its owners and also to the families of the crew. Whitby whaling captains were skilful seamen and in the eighty-four years the industry lasted, only thirteen Whitby ships were lost. Below is a painting by Webber showing Cook's crew hunting walrus and seals.

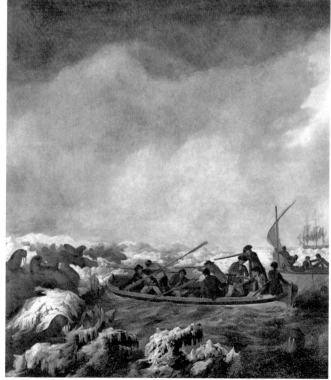

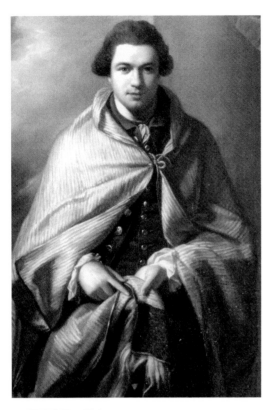

Back Home

On the return of Cook's voyages all manner of items, scientific, botanical and curious were brought back and displayed to the world. Banks himself (top), had befriended one of the two natives and, as a consequence, he brought the native Omai back to England. Omai was the first Polynesian to have set foot in this country and was the first to visit Cleveland in August 1775, dining at Mulgrave Castle among many short visits. Initially, Omai, who was from Raiatea and another native named Odiddy from Bora Bora, were taken on board as interpreters towards the end of Cook's second circumnavigation of the globe. Omai was introduced into London society and was an instant success. It is said he had gentle manners; he attended court and Joshua Reynolds painted his likeness (bottom). When Cook set off on his last and fateful voyage on 12 July 1776, Omai decided to return to his homeland. At Cape Town, South Africa, an incident occurred that reveals something of Omai's character. Four horses were taken on board and stabled in Omai's cabin. Apparently Omai willingly accepted this and Cook, in his last ever letter to Lord Sandwich dated 26 November 1776, wrote, 'The taking on of some horses has made Omai completely happy, he consented with raptures to give up his cabin to make room for them.' Not long after, Omai was repatriated with his countrymen and left the *Resolution*.

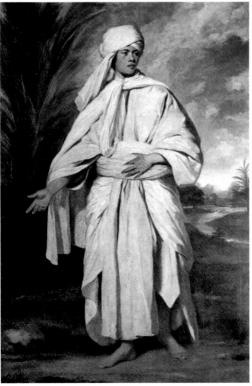

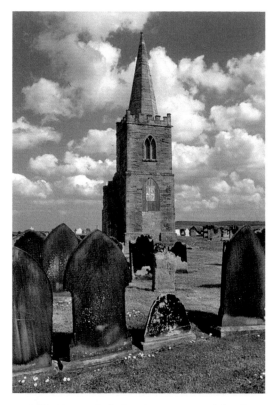

Church of St Germaine, Marske

With the death of his wife, James Cook's
father left Great Ayton in his old age to
live with his married daughter, Margaret,
who had married James Fleck at Redcar.
He died six weeks after his son was killed
in Hawaii in 1779, without ever hearing
the news. He was buried on 1 April 1779.
The Cook decadency was short and brief;
his wife, Elizabeth' was married to him
for six years when he began his long
voyaging. A further eleven years of her
married life were left to her, but the pair
met at infrequent, short intervals between
voyages. Elizabeth lost her husband and
all six of their children during her lifetime
and as a consequence, there was no one
to carry on the family line. Margaret and
James Fleck had eight children. Seven of
these married and at least one of them is
known to have had ten children. If the rest
of the family were as prolific, thousands of
descendants of James Cook could be living
today.

'James, the second of nine children,
was born in a mud cottage...That he
received only the rudiments of a formal
education is apparent from the style of
the original text in the Journal of his first
voyage. Yet how infinitely preferable,
is his own natural turn of phrase to the
inflated periods of the eighteenth-century
editor responsible for the version usually
reprinted as Cook's authentic journal.'
Christopher Lloyd, *The Voyages of Captain
Cook*, 1949.

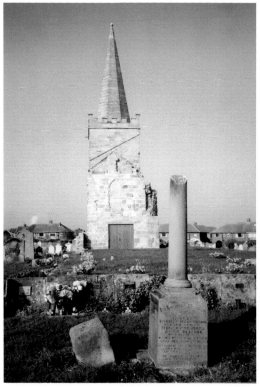

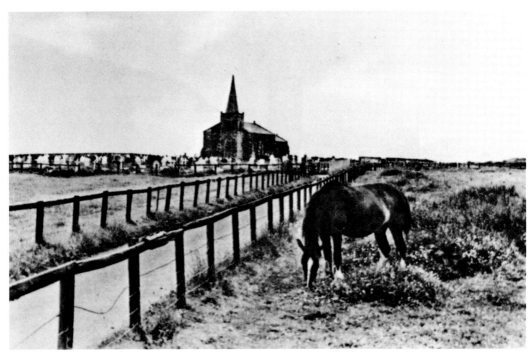

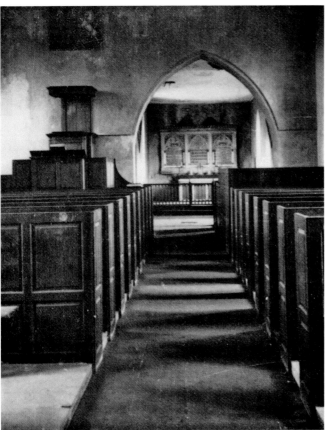

Church of St Germaine, Marske

Situated in fields on the cliff-top, the church served the community at Redcar and also the farms between Marske and Riftswood at Saltburn. Saltburn got its own place of worship in 1861. Later, due to the rapid rise in Marske's population, a new church dedicated to St Mark was erected in the centre of the Marske village around the time St Germain's was rebuilt in 1821. Apart from the occasional candlelit service, St Germain's fell into disuse and disrepair. The all-pervading sea-mists rendered the contents damp and ruinous. Eventually, in 1960, the body of the church was demolished, leaving only the tower and the steeple.

James Cook, Father & Son

James Cook, senior, was buried in the churchyard of St Germain's on 1 April 1779. His grave, however, was for many years left unmarked. It was probably his father's character that first shaped the boy James. While we know much about Cook's achievements, we know surprisingly little about the man himself. His Yorkshire boyhood gives us clues about his manner. He had an austere upbringing, in a family that had, of necessity, to be cost-conscious. Having brothers and sisters, he is unlikely to have been a spoilt child. Receiving little formal education, Cook was sometimes awkward in manner and unpolished in the phrases he used. If he was stolid, dour and rather taciturn, he would simply be showing the characteristics of many Yorkshire men with a rural background in the eighteenth century. The painter John Webber sailed as official artist in the *Resolution* on Cook's last voyage. He knew him from long experience. Herman Gill wrote, 'Webber's portrait shows us a face in which are written intellectual powers above the ordinary, and steadfastness of character, determination and energy. Here is no dandified wig, but the wearer's own hair pulled straight back into unsightly but serviceable pigtails. And there is a perplexity about the broad, sloping brow and commanding eyes, a compression of the sensitive lips, which hints that this business of sitting for a portrait is not pleasure. Cook, a truly great man, was a simple man.' Pictured right is London's famous statue of James Cook that stands near Admiralty Arch.

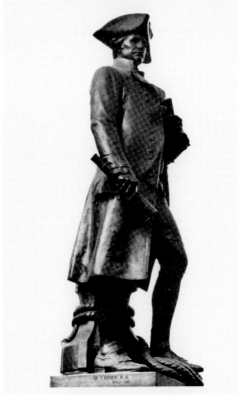

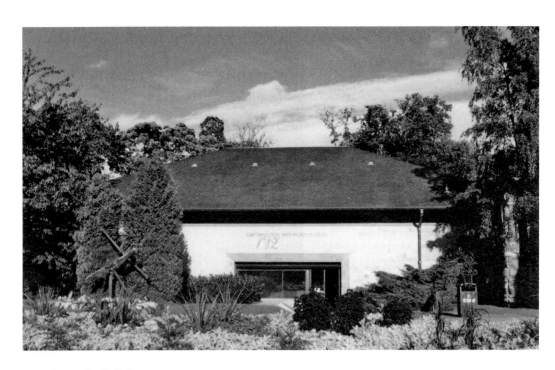

Captain Cook Birthplace Museum

With the loss of Marton Hall and the gift of the land to Middlesbrough, it was seen as an ideal moment to erect a suitable and lasting centrepiece within the 114 acre Stewart Park. On 27 October 1978, the 250th anniversary of his birth, the Captain Cook Birthplace Museum was officially opened. This award-winning museum with special effects tells the story of Cook's family, early life, naval career, his voyages of discovery and his worldwide influence. Outside, totem poles from the Pacific Islands watch over the museum entrance.

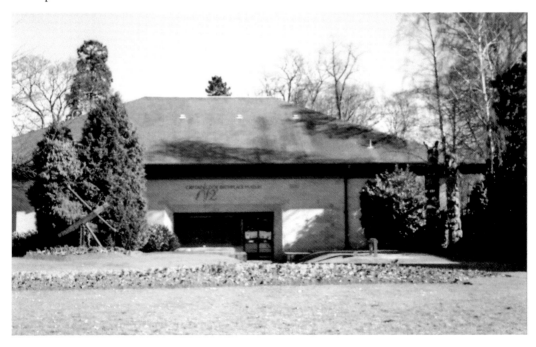

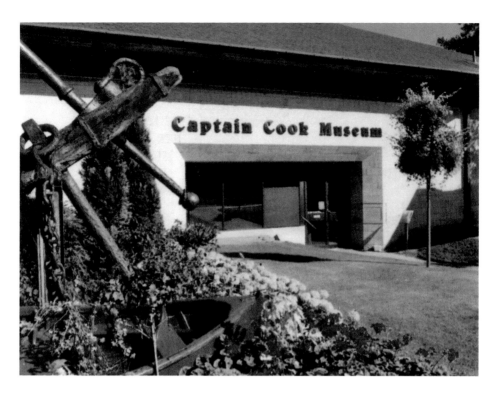

Captain Cook Birthplace Museum

Around the world are also a number of memorials erected in commemoration of James Cook. Two plaques have been erected on the Hawaiian Islands – the first is on the island of Kanai at Waimea, where Cook first set foot on Hawaiian soil from the *Resolution* in 1778 and the second plaque, fixed to the wall of the Library of Hawaii in Honolulu, is inscribed 'Captain James Cook, forerunner of modern civilization in the Pacific, in Hawaii, 1778-1779'. Cook is held in high esteem by present-day Hawaiians. In Alaska, a duplicate of the Captain Cook statue at Whitby gazes over the Pacific in a 50,000-acre leisure park at Anchorage, Alaska.

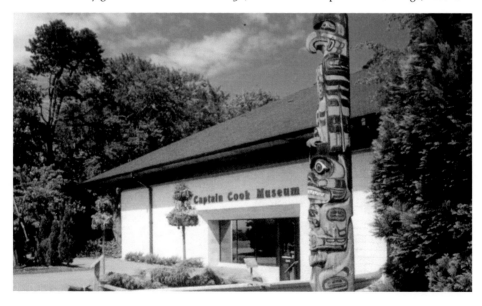

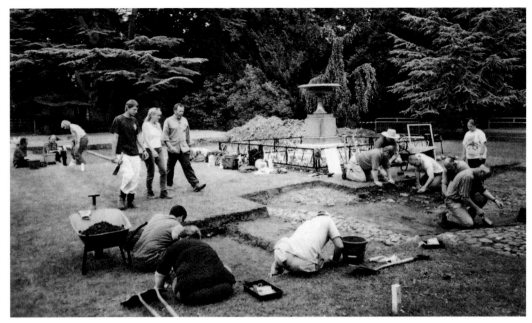

The Great 'Dig'

Volunteers worked with the Teesside Archaeology Society, the Captain Cook Birthplace Museum and Stewart Park on the 'Dig Marton!' excavation project to reveal evidence of the medieval village of East Marton in Stewart Park. Interestingly, the dig was sponsored by Middlesbrough Temperance Society and took place on Sunday 20 October 2003. The event was featured on the popular archaeological TV programme *Time Team* and all the cast took part. Below, the enigmatic massive carved figures found on Easter Island as painted by Webber, who illustrated many archaeological scenes on Cook's travels.

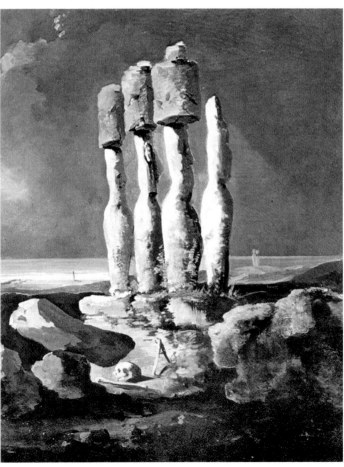

The Cook Memorial Urn

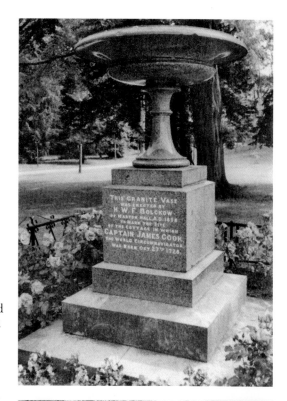

The Cook Memorial Urn, Stewart Park, Middlesbrough carries an inscription that reads 'This granite urn was erected by H. W. F. Bolckow of Marton Hall AD 1858, to mark the site of the cottage in which Captain James Cook, the world circumnavigator was born, 27 October 1728.' Over time, the setting has changed little, the trees have matured and the flower bed surrounded by traditional low cast-iron park railings has been landscaped and replaced with an inscribed compass rose. Today, there is still as much a fascination with the life and voyages of Captain Cook as there was when he died and, to assist in appreciating this story, a Captain Cook Trail exists. The tour is a circular route of around 70 miles (113km) with distinctive road signs from Marton in Middlesbrough to Whitby. You can join the tour anywhere and a booklet describes the route from Marton, which is the logical starting point if you follow Cook's from his birthplace. The tour can be completed by car in a single day, but to take full advantage of the Cook-related museums and attractions, the opportunities for short walks and soaking up the special atmosphere of Cook Country, you may wish to spend two or more days on your voyage of discovery. You can leave the main route at any point to enjoy local towns, villages and countryside. Accommodation of every type and price range is available *en route*.

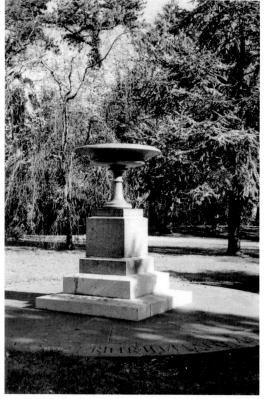

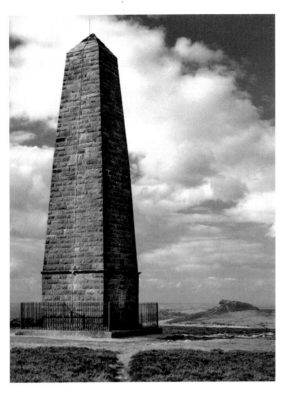

Captain Cook Monument, Easby Moor

On Easby Moor, above his childhood home of Great Ayton, the Captain Cook Monument was one of the first memorials to be raised in his honour by a Whitby townsman. The foundation stone was laid on 12 July 1827, the 156th anniversary of the day Cook returned from circumnavigating the world. The monument stands 51 feet high, 12 feet square and carries the inscription 'In memory of the celebrated circumnavigator Capt James Cook F. R. S. A man in nautical knowledge inferior to none, in zeal, prudence and energy superior to most. Regardless of danger he opened an intercourse with the friendly Isles and other parts of the southern hemisphere. He was born at Marton on 27 October 1728 and massacred at Owhyee 14 February 1779 to the inexpressible grief of his countrymen. While the art of navigation shall be cultivated among men, while the spirit of enterprise, commerce and philanthropy, shall animate the sons of Britain, while it shall be deemed the honour of a Christian nation to spread civilization and the blessings of the Christian faith among pagan and savage tribes, so long will the name of Capt Cook stand out among the most celebrated and most admired benefactors of the human race.'

As a token of respect admiration, the monument was erected by Robert Campion Esq., of Whitby AD 1827. By the permission of the owner of the Easby Estate J. J. Emerson, Esq., it was restored in 1895 by the readers of the *North East Daily Gazette*.

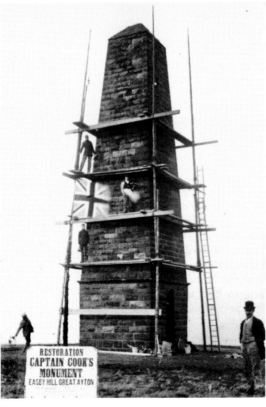

RESTORATION
CAPTAIN COOK'S
MONUMENT
EASBY HILL GREAT AYTON

The Eulogy

Sir Hugh Palliser, Comptroller of the Navy, Cook's friend and colleague over many years and the man who was the very first to recognise Cook's latent genius, erected a memorial in his own estate at Chalfont St Giles, Buckinghamshire that reads 'He raised himself, solely by his merit from a very obscure birth, to the rank of Post Captian in the Royal Navy, and was unfortunately killed by the savages of the island of Owhyee [Hawaii], on 14 February 1779; which island he had not long before discovered, when prosecuting his third voyage round the globe. He possessed, in an eminent degree, all the qualifications requisite for his profession and great undertakings; together with the amiable and worthy qualities of the best men. Cool and deliberate in judging; sagacious in determining; active in executing; steady and persevering in enterprising from vigilance and unremitting caution; un-subdued by labour, difficulties, and disappointments, fertile in expedients; never wanting presence of mind; always possessing himself and the full use of a sound understanding. "I, who had ambition not only to go farther than anyone had done before, but as far as it was possible for man to go..."'

Right, is an early nineteenth-century Rockingham figure of Cook after the famous portrait by Nathaniel Dance.

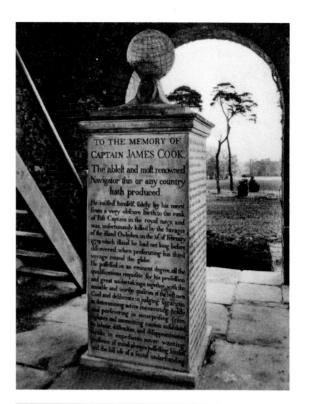

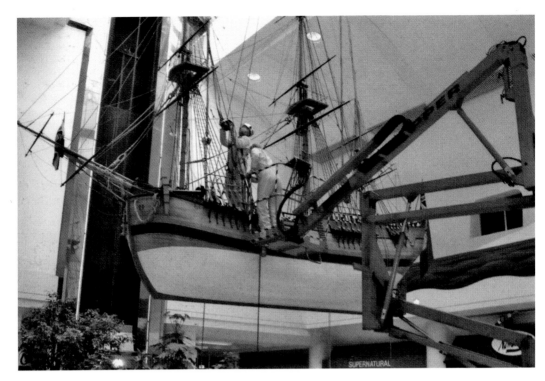

Latest Additions

The veneration of James Cook continues and with each celebratory event comes another addition to the monuments raised to commemorate his name and deeds. In Middlesbrough in 1963, a great modern shopping mall was erected, named the 'Arndale Centre'. Inside, a 50-foot-scale replica of the *Endeavour* was suspended from the roof, shown above. Sadly, the centre has made way for another phase of shops and facilities, and the replica is now under wraps at the Captain Cook Museum in Stewart Park, where it is no longer on public view (what a waste!). The final addition to Cook's catalogue of memorials is the 32-foot-high *Bottle of Notes* sculpture by Claes Oldenburg and Coosje van Bruggen, erected in 1993 near the town hall and now opposite the newly-opened 'MIMA' Art Gallery.